Conservation
and
Scientific Analysis
of Painting

Under the direction of Madeleine Hours, chief curator of the National Museums of France, Master of Research at the National Center for Scientific Research.

Conservation and Scientific Analysis of Painting

Madeleine Hours

VAN NOSTRAND REINHOLD COMPANY

New York Cincinnati Toronto London Melbourne

English translation: Dr. Anne G. Ward

Printed in Switzerland

Copyright © 1976 by Office du Livre, Fribourg (Switzerland)

Library of Congress Catalog Card Number: 76-7343

ISBN: 0-442-23549-6

Published in 1976 by Van Nostrand Reinhold Company
A division of Litton Educational Publishing, Inc.
450 West 33rd Street, New York, N. Y. 10001

Van Nostrand Reinhold Limited
1410 Birchmount Road, Scarborough, Ontario M1P 2E7, Canada

16 15 14 13 12 11 10 9 8 7 6 5 4 3 2 1

Library of Congress Cataloging in Publication Data

Hours, Madeleine, 1913-
Conservation and scientific analysis of painting.

Translation of L'analyse scientifique et la conservation des peintures.

Bibliography: p. 121
1. Paintings - Radiography. 2. Paintings - Conservation and restoration. I. Title.

ND1635.H6813 751.6 76-7343

ISBN 0-442-23549-6

CONTENTS

INTRODUCTION 9

PHOTOGRAPHY AND
RADIOGRAPHY 17

VISIBLE RADIATIONS 20

1 Tangential or raking light 21
 The condition of the surface 21
 The condition of the support 22
 The artist's style 24
2 Monochrome sodium light 29
3 Photomacrography 30
 The painter's style 30
 The condition of the layer of pigment 34
 Restorations 37
4 Photomicrography 37
 Signatures 39

DISCOVERING THE INVISIBLE 42

1 Ultra-violet fluorescence 42
 Varnishes 45
 Retouching 45
2 Infra-red rays 56
 Varnishes 57
 Signatures 59
 Pigments 59
 Infra-red reflectography 62
3 X-rays or Roentgen rays 63
 The support 67
 The paint layer 72

ANALYTIC METHODS 83

SIMPLE TECHNIQUES 83
 Microsampling 83
 Staining thin sections 86

Textile fibres . 90

ADVANCED TECHNIQUES 92
1 Pigment analysis 92
Spectrometry of emission in the
ultra-violet band 92
Spectrometry of X-ray fluorescence 93
X-ray microfluorescence 93
Castaing's electronic microprobe 93
Neutron activation 94
X-ray diffraction 94
2 Analysis of binding materials 94
Infra-red absorption spectrography 94
Gas phase chromatography 94
3 Methods of dating 96
Carbon 14 dating 97
Measuring isotope proportions in lead . . . 97
Neutron activation to measure
impurities contained in white lead 97
Natural radio-activity of lead 97

ENVIRONMENT AND
CONSERVATION 99
1 Climate . 99
2 Pollution . 102
3 Vibration . 103
4 Lighting . 104
Natural lighting 105
Artificial lighting 105

CONCLUSION 108

TECHNICAL NOTES 111

SELECTED BIBLIOGRAPHY 121

INDEX . 125

"There are times when I can clearly see a possible – and desirable – alliance between art and science, when the chemist and the physicist will be able to take their place beside you and enlighten you."

Louis Pasteur
March 6, 1865

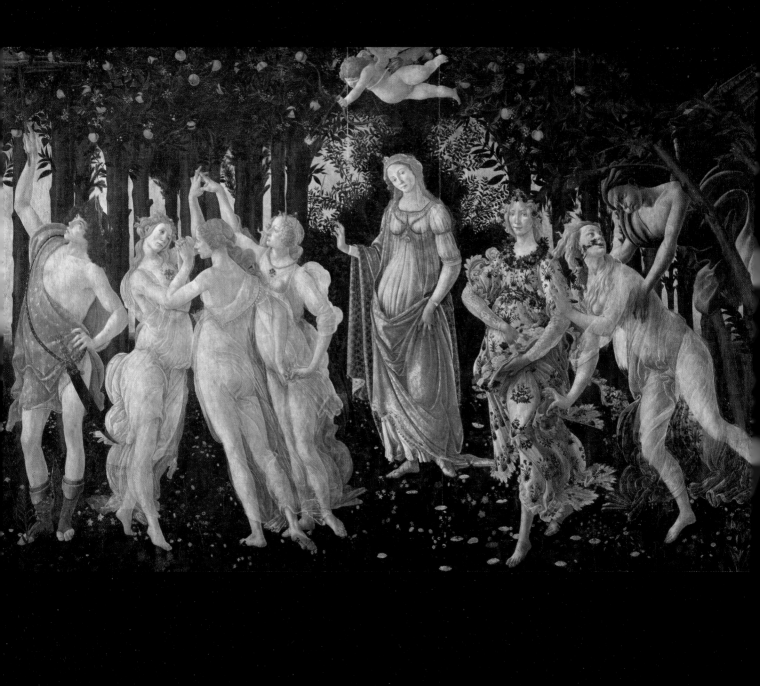

INTRODUCTION

A work of art is born first as an object and later becomes a message. A painting is a tangible object consisting of an infinite number of permutations on a finite number of substances, every one of which has its own physical properties. The painting may or may not be a masterpiece, but it can only withstand the passage of time and manifest the connection between the artist's conception and the pigments he used by means of these substances. The works of painters who are sometimes erroneously known as Primitives are a striking example of this. Botticelli's Primavera (ill. 1), for example, or the Master of Moulins' *Nativity of Autun* (ill. 2) still demonstrate the total mastery of the artist and the perfect state of preservation of his work. Other paintings carry within themselves the germs of serious radical deterioration, for example Ingres' *Portrait of Cherubini,* which is painted with bitumen (ill. 3); others again, like Leonardo da Vinci's *Battle of Anghiari,* which disintegrated within his own lifetime, incorporate the seeds of their own destruction. The science of conservation surely originates with public interest in works of art and the wish to preserve them and protect them from damage. There are a number of texts and treatises on the process of deterioration in paintings. It is no less certain that the gradual substitution of a canvas support for a wooden one and the practice of painting in oils which began in the sixteenth century rapidly accelerated the process of deterioration in easel paintings. The effects of time on the fabric can be seen with cruel clarity, especially when the basic rules of conservation have been ignored or transgressed.

1
Primavera, Botticelli (Uffizi, Florence).

Wars, iconoclasts and madmen also multiply the dangers of damage.
Additional factors, such as excessive light, heat, air pollution and vibration, are the product of our own times. Paintings are sensitive to changes of air, and do not like to be moved. The ills lying in wait for them are numerous, and their destruction more or less inevitable. The prospect is gloomy, but a new note of optimism is now possible because the life of a painting, like that of a human being, can be prolonged by modern science.

Only a few relatively simple measures are needed to conserve a painting in a good state of preservation. These measures could almost be described as a health regime, since paintings are the handiwork of human beings and have weaknesses as we all do. Caring for their health calls for the application of several rules: they must be kept in a stable, temperate atmosphere, avoiding extremes of light, radiation and pollution. These elementary rules, which are very often disregarded, will be the subject of a later chapter, since a knowledge of the importance of the environment in which paintings are kept and its regulation can help both connoisseur and expert to preserve them in good condition and to postpone for as long as possible the need for restoration, which is always risky, however skilfully carried out. If restoration becomes necessary the extent of the

2
When pictorial matter reaches this level of perfection, it expresses fully the artist's vigorous sense of what is beautiful, and seems indeed to defy the passage of time.
Photomacrograph of a portion of the Virgin's face, *Nativity of Autun* by the Master of Moulins (Musée Rolin, Autun, France).

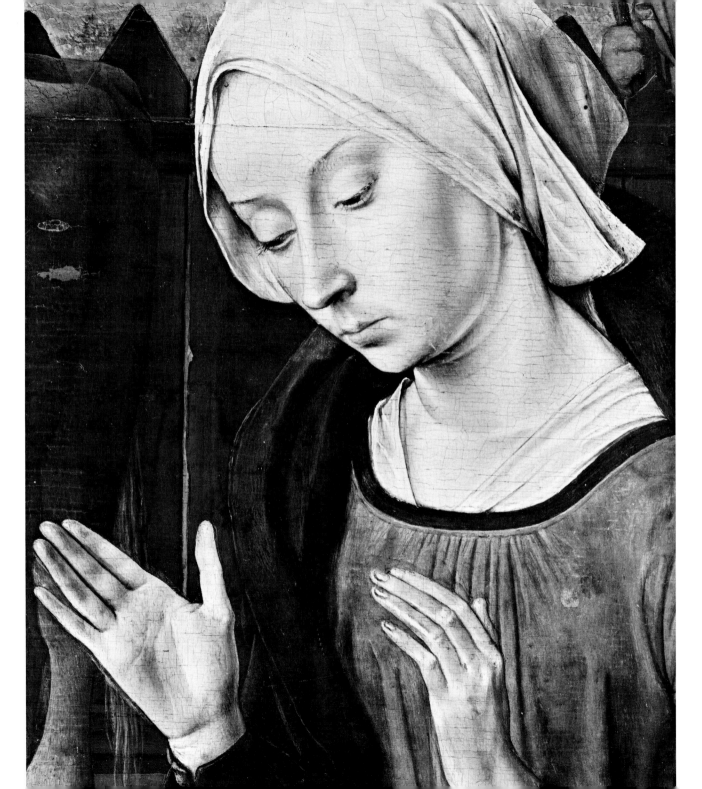

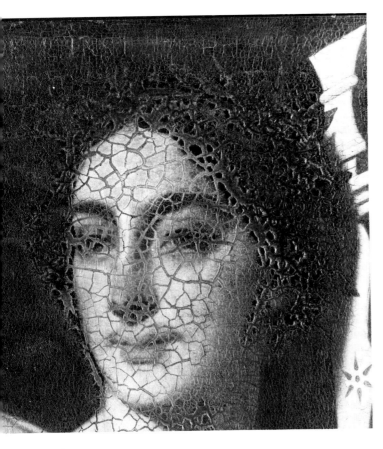

3
Ingres, like many of his contemporaries, used bitumen, an unstable pigment that made his paintings look lined and crackled. During his lifetime the artist witnessed this change and gave instructions that the varnish should never be removed from this picture, *Portrait of Cherubini* (Louvre, Paris).

preliminary examinations and analytical tests to confirm the diagnosis, or without making use of the technical resources which make the operation easier to carry out and more likely to succeed. The method of analysis should preferably be non-destructive and should enlarge the scope of our perceptions; for example the microscope which discloses imperceptible objects, and electromagnetic waves which show invisible things. Microchemistry and physics provide minute but accurate information on the structure of the artist's materials and their reactions to each other, on the possibilities of repair and on alterations to the painting by the artist or by earlier restorers. Scientific analysis can reveal not only the present state of a painting but the stages in which it was created and any changes made by human agency or the passing of time, after a short period of testing and a careful study of the evidence resulting from these tests. Formerly the connoisseur could only rely on his own eyesight, assisted from the eighteenth century onwards by a lens. Now all the resources of physics and chemistry are brought to bear to enable us to study the condition of a work of art, to follow the process of deterioration and to guide the restorer in his work.

As the dossier on the *Virgin and Child* of the Flemish School shows (ills. 4–8), these records take us on a thrilling journey through the pigments. Vanished images, preliminary sketches, repainting and alterations carried out in response to religious, political or purely social demands are shown by infra-red rays. Ultra-violet rays can measure the extent of earlier restoration, while the physicist and chemist can ascertain the inner structure by examining a microsample.

damage must be diagnosed, as in medicine, and the painter's technique and the qualities of the material must be fully understood; for this purpose scientific analysis is indispensable.

It would be inconceivable nowadays for anyone to put himself into the hands of a surgeon without

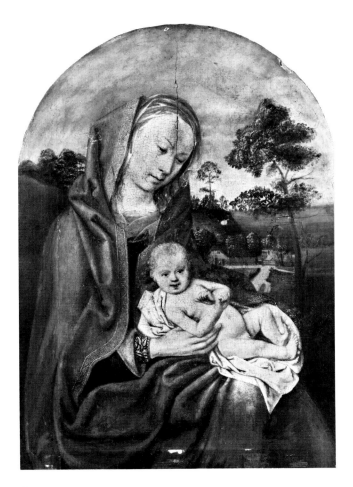

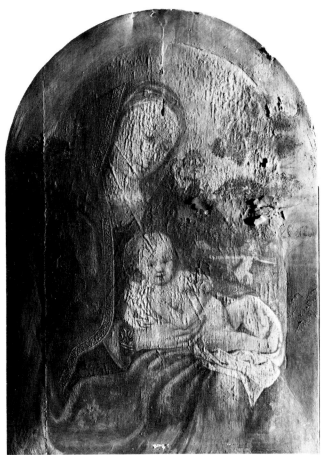

4

Fifteenth century *Virgin*, Flemish school (Louvre, Paris). Under normal lighting this picture hardly seems affected by age. But appearances are deceptive.

5

A tangentially-lit photograph shows the poor state of preservation. The wooden support is split in two places and the surface of the painting has lifted off in many areas. Strengthening and refixing are clearly necessary.

In the following pages researches currently in an experimental stage will be referred to briefly, since this book is designed basically to describe the increasingly important role of science in the study and conservation of works of art. It will not only describe current research but perhaps it will also give rise to new ideas and lead to a fresh understanding of the demanding work of the restorer. The modern restorer is an expert searching primarily for the truth, who respects the original work of the artist and who is not seeking to make a painting conform to contemporary taste but to prolong its

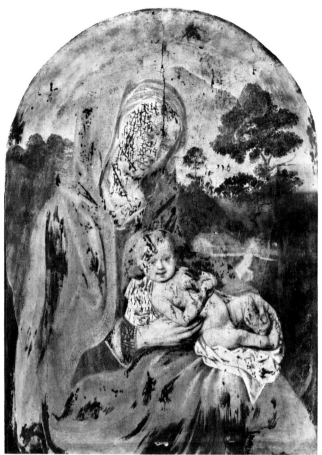

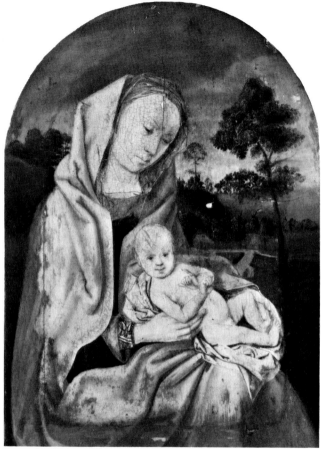

6
A photograph taken by ultra-violet light shows up dark patches indicating extensive repainting on the Virgin's clothing and retouching of the face.

7
Infra-red radiation reveals only a small amount of major retouching, but it does clearly mark the shape of an old enlarged version of the picture which had already been hinted at by examination under the other kinds of radiation.

life by appropriate treatment, to remove earlier retouching and alteration, and to detect changes, since they are not always the work of the original artist. People with more goodwill than discrimination sometimes succeed in altering the appearance of a work for reasons which usually have nothing to do with principles of aesthetics or conservation, and in the course of these transformations the painting loses its pristine beauty. Modern restoration aims not only to carry out rescue operations, but to remove as many as possible of the additions made during the course of the years.

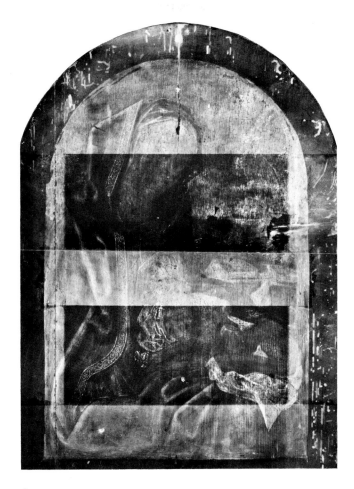

8

X-ray photography, the ultimate method of in-depth examination, reveals major alterations in the painting and its support. This is a representative collection of evidence for the way scientific photography can help to preserve pictures.

When the restorer and the scientist collaborate under the direction of the historian, the connoisseur, the museum director or the owner of a painting, they should be able to save a painting, restore it to its original condition and combat the effects of time. We can best protect our cultural heritage by sharing artists', craftsmen's and scientists' experiences; by publishing the secrets of each studio; by combining traditional methods with the discoveries of modern science; and by sharing all research and studies. This combination should contribute to international awareness of the problem, since "our era has the honour" of seeing nations work together to preserve the arts.

There were formerly two ways to arrive at an understanding of a work of art: poetic feeling and history.

If it is accepted that scientific analysis of a tangible object such as a painting can lead to a better perception of an intangible factor such as the artist's message and a closer understanding of such a complex conception as a picture, then this new road to understanding a work of art must be regarded as being independent of the two earlier ones. The notion of utilizing science to analyse works of art was born in mid-eighteenth century Europe. This is attested by the reflections of the Comte de Caylus, and the work of the physicist Charles in the 1780s is an early experiment in the grand design of science in the service of the arts.

The work of Bianchi and Fabroni in Italy, that of Sir Humphrey Davy in England, Geiger in Germany and Chaptal and Vauquelin's research in colour chemistry in France, which was soon followed by that of Chevreul and Pasteur, should also be mentioned; but it was Niepce and Daguerre's invention of photography which made it possible to examine both the visible and invisible aspects of a painting. These methods of analysis are carried out without damaging the painting, by using the properties of

electromagnetic waves to illuminate and penetrate the pigment. This type of examination can include the whole painting or a large part of it. It should start at the surface of the work and continue through to the support in the case of a picture or a flat document, and to the centre in the case of a free-standing sculpture.

PHOTOGRAPHY AND RADIOGRAPHY

For centuries art historians have tried to trace the lives and work of artists and explain and comment on their paintings, but very rarely to describe them. The practice of engraving paintings and the search for a mechanical means of reproducing images did not begin to spread until the seventeenth century. Darkened rooms, drawing aids, physionotracing and the *camera obscura* all had their vogue and awakened an interest which extended far beyond the narrow circle of academic experts. Experiments by the physicist Charles and by Wedgwood and Davy in England in the late eighteenth century, and the invention of lithography in the early nineteenth century, were all directed towards the discovery of a means to reproduce paintings. Nicéphore Niepce's early experiments, which lasted from 1822 until the invention of photography, all tended the same way, and one of this learned man's first heliographs was of a Claude Lorraine landscape. This is why, when Arago reported Niepce and Daguerre's discovery to the Paris *Académie des Sciences* on January 7, 1839, he asked, "Can photography serve the arts?" The answer was affirmative.

A century has passed. The popularity of books on art and museum research and, in France, André Malraux's works (especially *Museum without Walls*) are a striking demonstration of the role of photography in the dissemination of cultural aesthetics.

Photography, which some people regard as an exact and objective means of reproduction and others as an art form, has gone through the same stages of evolution as scientific thought, losing some of the qualities which were over-generously attributed to it at first, among them its objectivity. Photography has become increasingly important, and its role is greater with every passing day. Originally devised to reproduce lines, it soon tackled the problem of values and colours; it then passed beyond overt appearances and began to produce images of the invisible. It is not the least of contemporary photography's miracles that it enables us to see things which were once invisible, and thus enlarges the scope of our perceptions.

Indispensable for inventories of works of art, and easy to classify, photographs are a great help to the

historian and the expert. They also play an essential role in conservation; here it is exclusively their function as an aid to methods of analyse that we wish to emphasize.

Examination under electromagnetic radiation is informative but temporary. Its efficacy depends on the skill of the observer. Photographs record and preserve evidence of a moment's observation; they can also substitute for the naked eye in cases where it is unable to register the effects of such invisible radiation as infra-red.

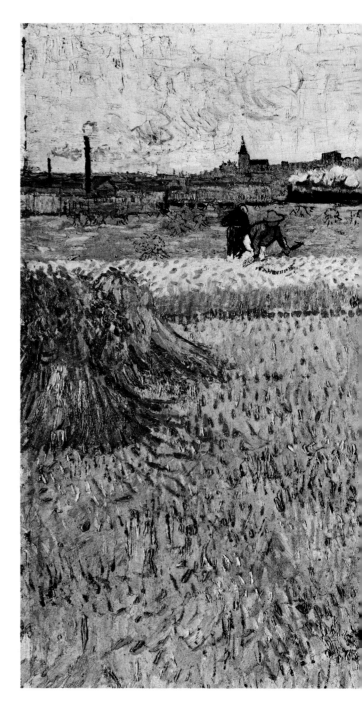

9 and 10
The beam of tangential lighting animates the picture and brings out the fervour that inspired Van Gogh when he painted *The Harvest* (Musée Rodin, Paris).

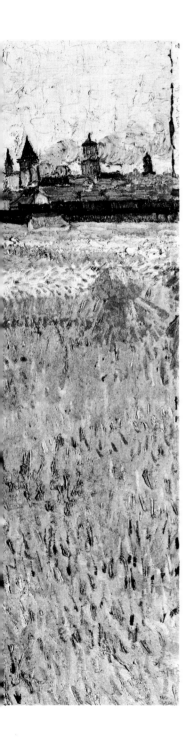

19

VISIBLE RADIATIONS

Light is a form of radiating energy which affects the visual arts of painting and sculpture and is the most valuable source of information to the art historian and expert. It can be diffused or condensed to enhance the power of the human eye. It can be passed through a camera to preserve a permanent record of a transient moment. Many types of artificial lighting have been devised to improve visibility in art exhibitions.

Tangential, raking or direct light can be used to analyse the surface of a painting. They bring out the characteristics of the painter's style, touch and rhythm, highlight *impasto* and glazes and indicate the condition of the support, be it wood or canvas. Ultra-violet rays or their fluorescence can show up changes in the surface, retouching, repairs, removal of varnish, faked inscriptions, repaired signatures, etc. while the penetrating power of infra-red rays at the other end of the spectrum clarifies obscure texts, reveals inscriptions and signatures which have disappeared or been deliberately hidden, and shows the intermediate stages between the sketch and the finished work. X-rays are even more penetrating, and can bring out retouching by the artist, details of the condition of the support and sometimes an original sketch which is different from the finished work. They reveal the originality of the painter's technique, his personal touch and the previously invisible stages in which the work was constructed. Radiography has a vital role to play in art history and conservation. Investigation of this type produces records and photographs with a common denominator; they can be compared with the completed work and they reveal its successive stages and how it has deteriorated in the course of time. They are images of the invisible, and sometimes images of the painting's past history.

11
This photomacrograph shows up particularly clearly the damage to the picture. On the right the film of varnish is lifting off, on the left the painted layer is coming away.

1 Tangential or raking light

In this process a painting is placed in a dark room and lit by a beam of light parallel to or forming a very small angle with its surface, so as to show up in relief any irregularity of the surface. Different views of the panel or canvas can be obtained by varying the position of the light source. The nature of the light source can also vary. It can be a ray of sunlight penetrating through an aperture to one side (e.g. a window covered so as to admit only a pencil of light), or an arc lamp with the beam condensed by a lens, or simply a spotlight or projector provided with side shutters which make it possible to regulate the strength and direction of the beam. It should, if possible, be parallel with the surface or form an angle of between five and thirty degrees with it.

Visual examination of a painting or photographs of it taken by this light can provide invaluable information on its state of preservation and on the painter's technique. The effect is very different from the normal view (ills. 9–10). It distorts reality but discloses imperceptible details of the condition of the layer of pigment and the support by accentuating the slightest relief.

The condition of the surface

Raking light is essential for checking the state of preservation of paintings. By emphasizing any irregularity or relief on the surface, it brings out the condition of the layer of pigment and indicates any damage to the varnish; once this is ascertained, a preventative conservation policy can be planned. This simple method of examination reveals the most minimal peeling, rudimentary blisters, the slightest separation between the pigment and the support, any warping of the wooden panel, splits in the boards or damage caused by any kind of mechanical stretching. The position of the light source in relation to the painting must be varied so that the beam forms an acute angle with the surface and illuminates the surface both laterally and vertically. All these views can be recorded photographically so as to keep a permanent record of the surface and the number, extent and seriousness of any cracks (ill. 11). This check is indispensable, and should be carried out every time the picture is moved to a new

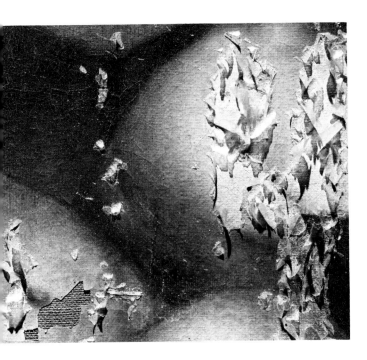

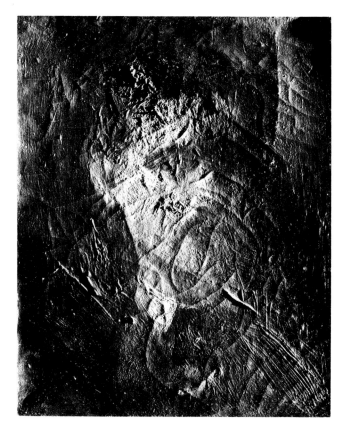

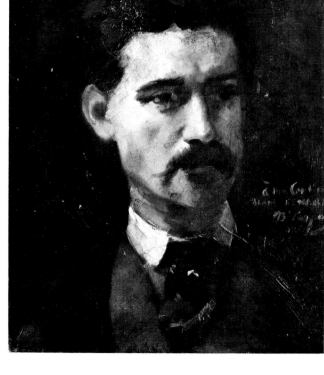

12 and 13
This enigmatic picture is in fact that of a painting on canvas which has suffered severe damage and appears blistered and spoiled. Seeing the painting under normal light makes it impossible to gauge the precise extent of this damage, but comparing the two pictures emphasizes the need for intervention. *Portrait of a Man*, Carpeaux (Musée des Beaux-Arts, Pau, France).

position. Flaking in its early stages is easily repaired but, as it advances, it forms scales which come away from the support. Refixing is difficult and can diminish the value of the work.

Considerable disasters can be avoided by regular checking. Photographs provide a simple and accurate record to guide the restorer or expert in his work, but the value of this technique is most apparent in the study of the wooden or canvas support.

The condition of the support

A canvas support can sometimes become slack because of changes of atmosphere. A slack canvas can look so warped and buckled that the picture is almost unrecognisable, but this disturbing manifestation is not necessarily serious (ills. 12–13). When the support is a single piece of wood, tangential light will reveal any curves and distortions, and

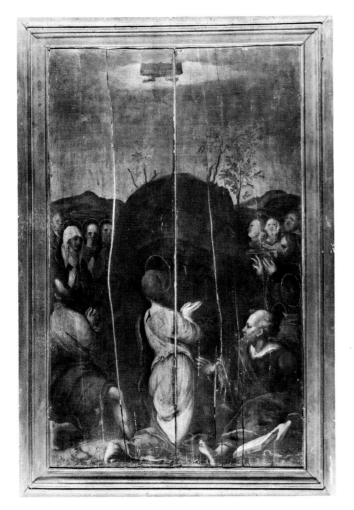

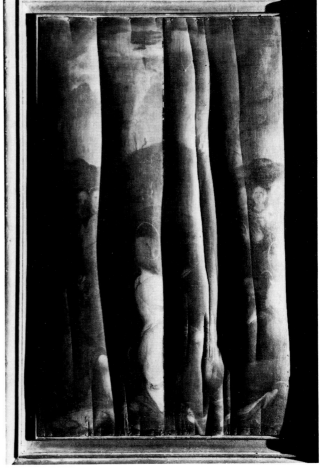

14
Sixteen-century, French school *The Ascension* (Musée Boucher de Perthes, Abbeville, France). Painting on wooden backing which seems to be split in several places.

15
A photograph under surface-level lighting, confirms the state of the wood mounting and clearly shows warping and splitting calling for urgent restoration.

these can be flattened before any breaks and splits occur. When the panel consists of several boards, their interaction and the joints between them can be observed by this method (ills. 14–15).

Some curious additions, restorations and incrustations which the original has amassed in the course of time appear on photographs taken by raking light.

Most paintings dating before the seventeenth century were executed on wooden panels; some have been transferred to canvas in recent years. Raking light will show whether a painting now on canvas was once on wood. The picture always bears marks of its original support which are invisible to the naked eye. Oblique light shows up knots in wood and divisions in the panel which is no longer there. This is true of the *Portrait of François I* in the Louvre, now on canvas. Photographs taken by raking light clearly show the four boards which formed its original support (ills. 16–17).

This process can also reveal the presence of a sheet of paper between the layer of pigment and the support. A number of painters executed their work on paper and then attached it to a support. This is true of more than one famous Corot painting.

A paper support is usually too smooth to be visible, but under a beam of raking light small folds resulting from the original gluing can sometimes be seen, and they betray this type of material.

Panels on copper can be recognized at a glance, but pigment does not always adhere well to metal. The onset of peeling can be measured by the use of raking light.

The artist's style

A painting is basically a surface covered with colours arranged in a certain order. The old masters generally built up their works in a series of layers. Having prepared – or had someone prepare – the wooden or canvas support by covering it with white

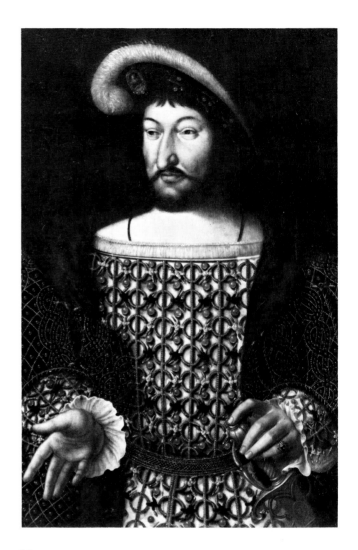

16
Early sixteenth century, French school: *Portrait of François I* (Louvre, Paris).

17
Surface lighting reinstates in this picture which was transferred from wood to canvas in the last century, traces of the four planks of wood, now lost, which have left their impression on the painting. Details of a work of art history are thus yielded up by this procedure.

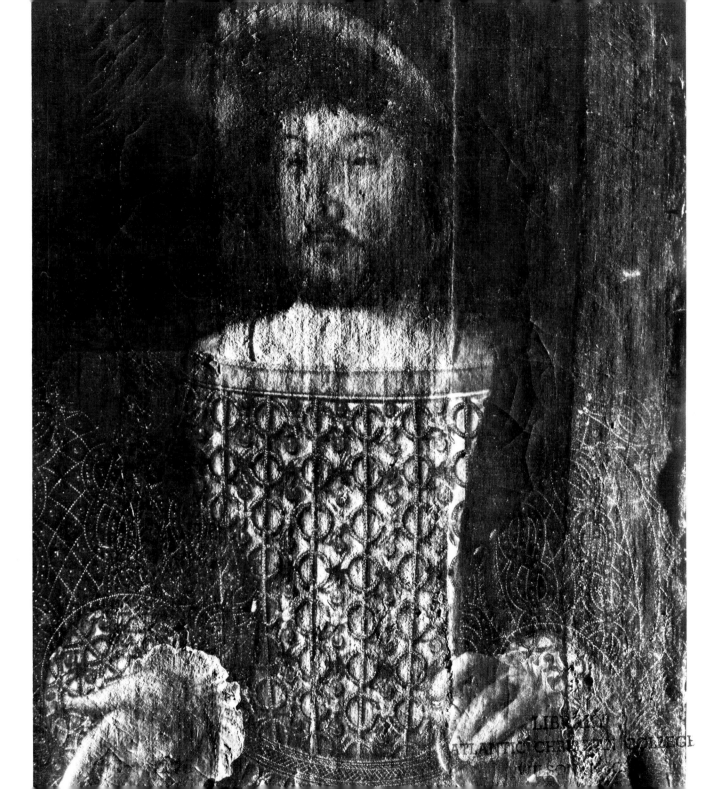

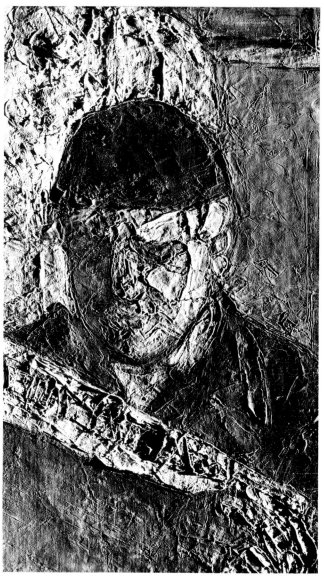

18
Portrait of the Artist's Father, Cézanne (National Gallery of Art, Washington, D.C.).

19
Tangential lighting brings out wonderfully the strength and rhythm of the artist's palette knife or brush in modelling his father's face. It tells us more about Cézanne's craftsmanship than about the state of the picture.

or tinted primer, they began to work. Design and sketches brushed in with varying degrees of detail provided the foundation for the layer of pigments, which might be applied with a large brush or a palette knife. The pigment itself is arranged in a series of thick layers or thin glazes. Highlights are often indicated by touches forming crests. Paintings executed in a series of layers can easily be studied by tangential light. It shows the directions of the strokes and supplies a check on the condition of a painting which has undergone remounting or a change of location, since repair work carried out with a hot iron sometimes involves the risk of destroying the *impasto*.

Raking light can both check the state of preservation of the pigment and provide evidence of the artist's style (ills. 18–19). This technique should be used whenever photomacrographs are taken. Here too the direction and angle of the beam of light can produce some highly illuminating information, as in the case of some photomacrographs of Van Gogh's work (ill. 20).

20
Photomacrograph of Van Gogh's handwriting.

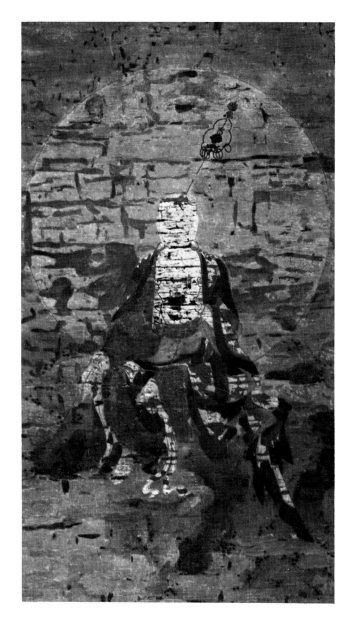
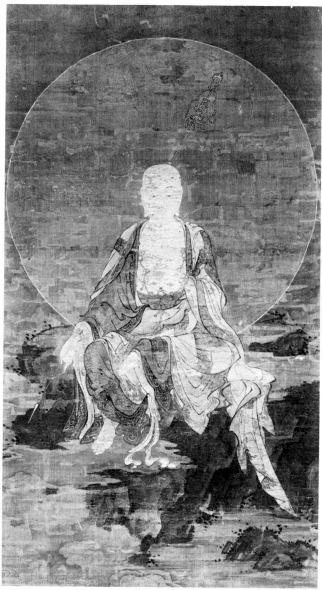

21 and 22
Ultra-violet fluorescence enables us to measure those parts of this Chinese buddhist painting of the Sung Dynasty which need retouching. The photograph under sodium vapour lighting brings out the fine draughtsmanship of this composition on silk (Musée Guimet, Paris).

2 Monochrome sodium light

Visible light consists of a number of rays, the wavelengths of which lie between 380 and 760 nanometres. This interval defines the limits of the visible spectrum. Monochrome light is emitted by rays with a fixed wavelength such as sodium light, which is actually a doublet, i.e. it has two rays: D1 589 nm and D2 589.6 nm.

A light used for examining paintings consists of a U-shaped tube with a positive electrode in a vacuum. When sodium vapour is electrically excited it produces pure yellow light. Similar lights are used for motorways and sports grounds. They have another property; as well as the yellow sodium doublet they emit another invisible doublet which lies in the infra-red band at 818.3–819.4 nm, and which can be used for lighting infra-red photographs. This kind of light is particularly useful because, after the lamps have warmed up, direct examination can be carried out and accurate observations obtained. Furthermore, the painting can easily be photographed on panchromatic film without using a filter. The resulting photographs are sharper than daylight prints because there is no selective diffraction in the lens (ills. 21–22).

It is easy to see that monochrome light makes for clearer visual examination and sharper photographs than white light because it suppresses all chromatic aberrations. Variations in reflection which are scarcely visible in white light are also detectable, betraying any retouching or repainting under the varnish.

Since the light of a sodium vapour lamp is yellow it alters colours radically. Blues and violets look black while greens, oranges and reds give a series of greys.

Yellows are exactly rendered. This type of light penetrates the outer layers of the painting, i.e. the varnish and the glazes. As the colours disappear from the spectator's view he discovers a stripped-down and rejuvenated work, as it was before it was finished. The painting shows what it looked like while the artist was working on the drawing and preliminary stages.

Pure yellow light makes it possible to take a direct monochrome view of the picture which is not dissimilar to that of an exceptionally sharp photograph. The properties of this type of light are very like those of infra-red light except that infra-red light needs the medium of a camera. It makes it possible to assess the quality of the whole subject with the naked eye and to read all or part of a defaced inscription immediately. It is an effective supplement to examination by natural light. When the effect of colours on the retina is suppressed, the value of the lines can be better appreciated. When examining copies and forgeries it is useful to be able to abstract the colour for a few moments and study only the weakness of the design and drawing; and another particularly useful quality of monochrome light is the fact that it suppresses the effect of tinted or dark varnishes which obstruct the vision and make it hard to read inscriptions and signatures, and brings out unsuspected details in obscure passages. Examination by sodium light before varnish is cleaned off will show some details that were hitherto not thought to exist. When Leonardo da Vinci's *Virgin of the Rocks* was being studied prior to restoration (it had been damaged during the nineteenth century by a change of location and a coat of bitumen varnish) sodium light emphasized the

quality of the painting and the profundity of the composition, and encouraged a highly satisfactory restoration.

This type of light also makes it possible to read inscriptions on the frame at the back of the painting, illegible labels or signatures covered with paint. It is not as effective as infra-red light, but it can provide a view of the painting as it would look when cleared of varnish or mould before the restorer has taken the first steps to remove the varnish.

3 Photomacrography

Photographic technique will not be described here except for the types which expand our vision and enrich our perceptions. This is the case with photomacrography and photomicrography.

Before describing these techniques it would be as well to define them, since they are frequently confused.

In both cases a real image is enlarged. In photomacrography the camera enlarges a visible image slightly (to the power of ten at the maximum). In photomicrography an image which is invisible to the naked eye is photographed by means of an optical relay consisting of a microscope which produces enlargements to the power of 10 to 1000 in the case of an ordinary microscope, or 30 to 40,000 in the case of an electron microscope. Again, enlargements can be made from a life-sized or smaller print, but photomacrographs are preferable since they preserve all the clarity of the original print, and photomicrographs are preferable to enlarged photographs.

The word photomacrography is used to describe the technique for obtaining slightly enlarged pictures without the use of a microscope. The photograph is taken with a camera fitted with an extended bellows and a lens with a short focal length which obtains the desired enlargement. Photomacrography can be carried out by daylight or by various forms of artificial light such as tangential, white, sodium, etc. The linear or superficial enlargement of the print must always be recorded.

One of the advantages of photomacrography is that it isolates specific parts of the painting from their context and concentrates on details the attention which is usually distributed over the whole picture; it educates the eye and it heightens the interest of details which the naked eye tends to overlook, and correspondingly enlarges the range of our perceptions and aesthetic responses.

Van Eyck might almost have foreseen this process; his work is full of barely-visible details which, when enlarged, proved full of surprises for the connoisseur.

It should be noted that some photomacrographs are interesting not only by virtue of the magnification but because of the fact that they isolate a specific part of the painting and concentrate on the detail the response which is usually generalized. A good example of this is Van Gogh's *Portrait of Dr.*

23
By emphasizing the rhythm and line of the artist's brush, photomacrography intensifies the impulsive artistry of Van Gogh. *Portrait of Doctor Gachet*, (Louvre, Paris).

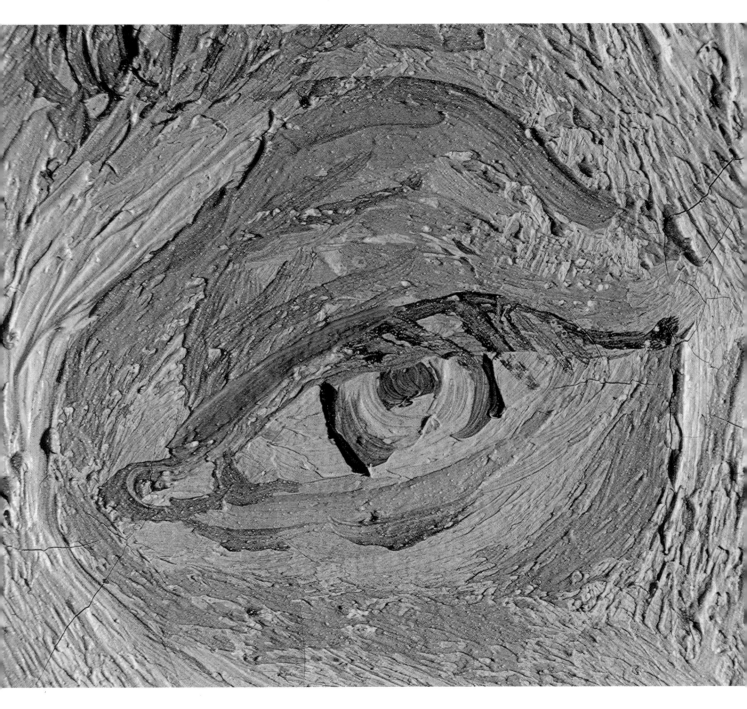

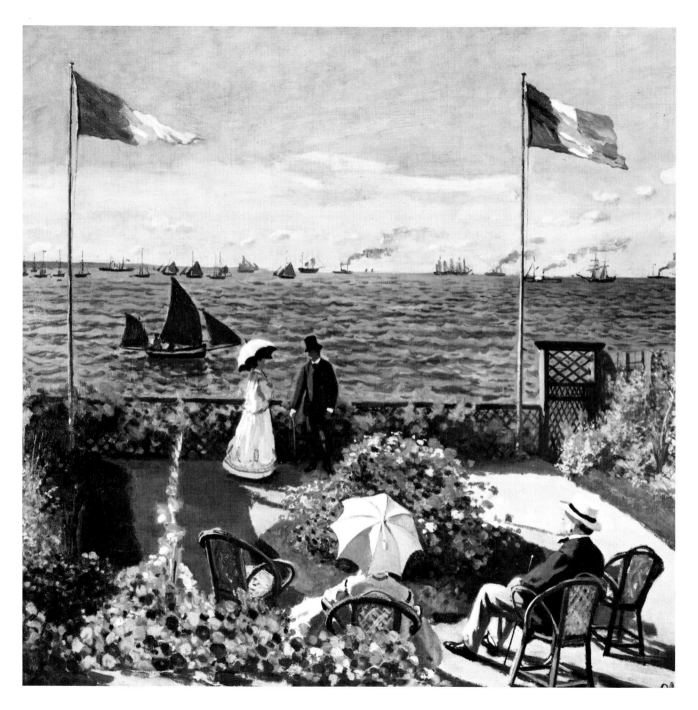

Gachet. Photomacrographs bring out not only the technique but the emotion with which this detail is charged (ill. 23).

Enlargements also reveal more of the painter's touch; when the figures in the painting are no more than a few centimetres high, the enlargement enhances the painter's use of the figures in his work, his technique and his method of emphasizing the essential character of the figure with one clear feature. It is interesting to observe to what extent the quality and force of the style remain perceptible. The painter's message and the emotion it rouses in us are both magnified. It is obvious that enlargement is also a test of quality. Under photomacrography a small master-painting still shows all its quality. A poor painting, on the contrary, will display all its weaknesses when submitted to the same enlargement. In an enlargement to the power of five or ten it is difficult to be unaware of faults which would be insignificant to the naked eye. This is therefore a simple way of spotting forgeries or repairs.

The painter's style

Photomacrographs sometimes display not only the technique but the style of a painter, for example the print of Claude Monet's *The Terrace at Sainte-Adresse* in the Metropolitan Museum of Art, New

24
The Terrace at Sainte Adresse, Monet (Metropolitan Museum of Art, New York).

25
Photomacrography by slightly raking light emphasizes the brushwork and the masterful and high-strung quality of Claude Monet's artistry.

33

York, which brings out the vigorous touch with which the face was executed, the beauty of the pigment which is very thick, the firm contours, and the quality of boldness and suppleness in the brushwork which are typical of the painter's technique (ills. 24–25).

The condition of the layer of pigment

Photomacrographs can reveal the condition of the actual layer of pigments. The skin of paint is composed of a number of superimposed layers which are submitted, from the moment the painter lays them on the support, to a combination of complex ageing processes arising from physical and chemical reactions and the laws of mechanics. One of the most obvious and serious consequences of the passage of time is the appearance on the surface of a painting of flaking and cracking of varying depths (ill. 26).

Old paintings are usually covered with as many as three networks of cracks (ill. 27). These cracks are gradually formed by the traction of the various materials used in building up a painting. This traction varies according to the coefficient of expansion of the materials when the temperature and humidity of the atmosphere change.

Almost every painting is covered with a network of cracks caused by the pull of the support or the nature of the binding agent. Its form varies according to the thickness and consistency of the primer. Craquelure dating to the thirteenth and fourteenth

centuries looks large and irregular on paintings on soft wood, and fine on Flemish Primitives, which are usually painted on oak. These cracks take the form of a fine grid or a series of concentric circles. Craquelure of this latter type is known as cobweb, and is characteristic of late eighteenth century French painting (ill. 28).

Details of craquelure can be seen clearly on photomacrographs. The edges are sharp and precise in the case of craquelure photographed on a seventeenth century painting in good condition. However, when a painting is not properly dry and is finished off by baking in an oven there will be a degree of subsidence, and this will produce a lot of flaking; this is the case in many forgeries. The photograph shows the width of the furrow between the edges of the cracks. Forgers sometimes draw or paint a fine web of cracks over the whole or part of a painting when it has not reacted sufficiently to oven-baking or the use of a drying agent. These faked cracks are then covered by a thick layer of tinted varnish which makes it difficult to examine them with the naked eye or a magnifying glass, but a photomacrograph taken in a good light shows the difference between this type of pattern, which is usually random, and genuine craquelure, which usually takes a logical form imposed by the pull of the materials of which the painting is composed.

The appearance of the craquelure often betrays a forgery or a localized repair; restorers sometimes take it on themselves to restore damage to the pig-

26
Photomacrograph showing crackling of coloured pigments; the gold on which the picture is painted is coming away.

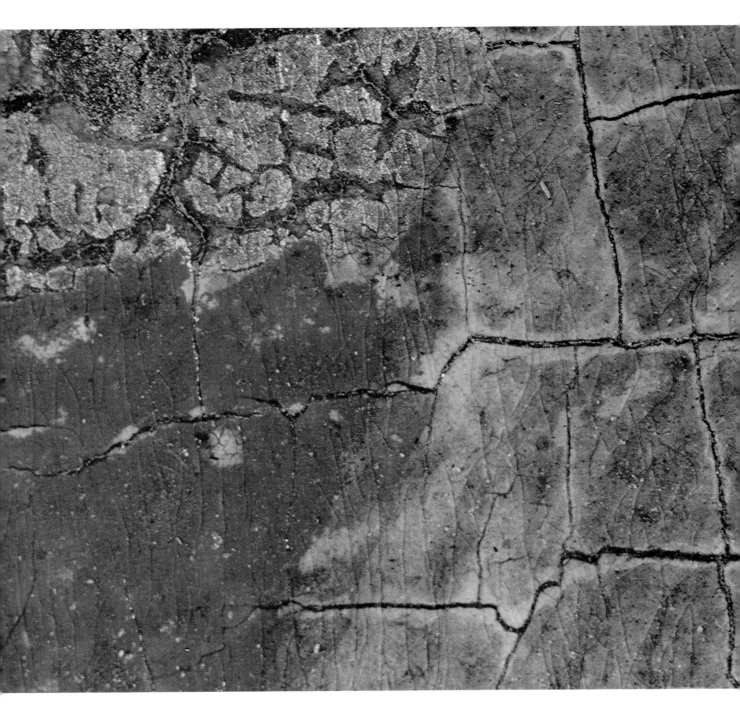

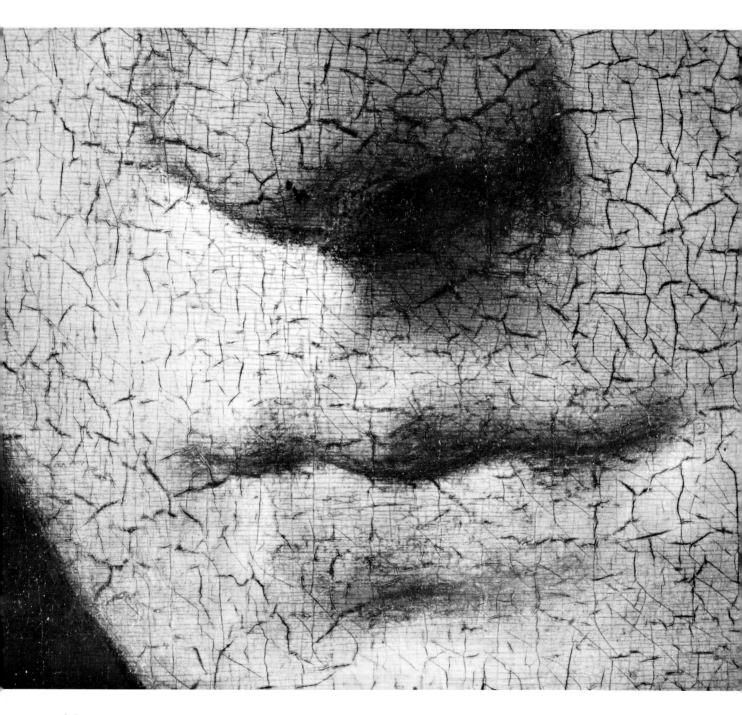

36

ment, and repainted areas are affected by false cracking.

Cracking in the varnish forms a separate network which is usually easy to distinguish from that of the primer.

define the evolution of a painter's style and technique by pointing up differences and similarities.

Restorations

The extent and appearance of localized cracking can be examined through a magnifying glass, but examination of the whole painting makes it possible to detect repainting. When repainting is light and transparent and covered with varnish, it is difficult to see by ultra-violet light. Photomacrographs make it possible to assess its extent. Restorations which post-date the original work break into the network of cracking which usually begins to appear a few decades after the painting is completed; a break in the network indicates the extent of the repainting. All the most minute elements of the painting's surface should be the subject of photomacrographic studies, which should sometimes be supplemented by the use of a microscope.

Comparative studies of the details of other works by the same master or school can make it possible to

4 Photomicrography

By means of a microscope and photomicrography – regularly used to examine paintings – an actual image can be enlarged, observed and recorded. Slight magnification obtained with a binocular magnifying glass or a microscope is often also employed. However, the limited field of the microscope does nothing to enrich aesthetic perceptions. Its function is to penetrate the secrets of the pigment itself rather than to detect a detail designed by the artist.

There is a significant difference between using a microscope or binocular magnifying glass and taking a photograph. Microscopic examination is a superficial examination of a painting or fragment of a painting resulting from a great number of successive images. When it is carried out by an eye which has been trained to detect any anomalies which may appear and locate them on the painting, it is an invaluable process.

Slightly enlarged photomicrographs can verify the state of preservation of the varnish. This is often applied in a number of successive layers, and is subject to deterioration. They also make it possible to check the adherence of the layer of pigment, wear and tear on the glazes and various kinds of damage

27
Photomacrograph of the smile of Leonardo da Vinci's *La belle Ferronnière* (Louvre, Paris) emphasizes the subtlety of the modelling and the threefold network of cracks in the painting; the fine cross-rules in the substances used for preparing the surface; the crackling of the painted layer and the cracking of the varnish.

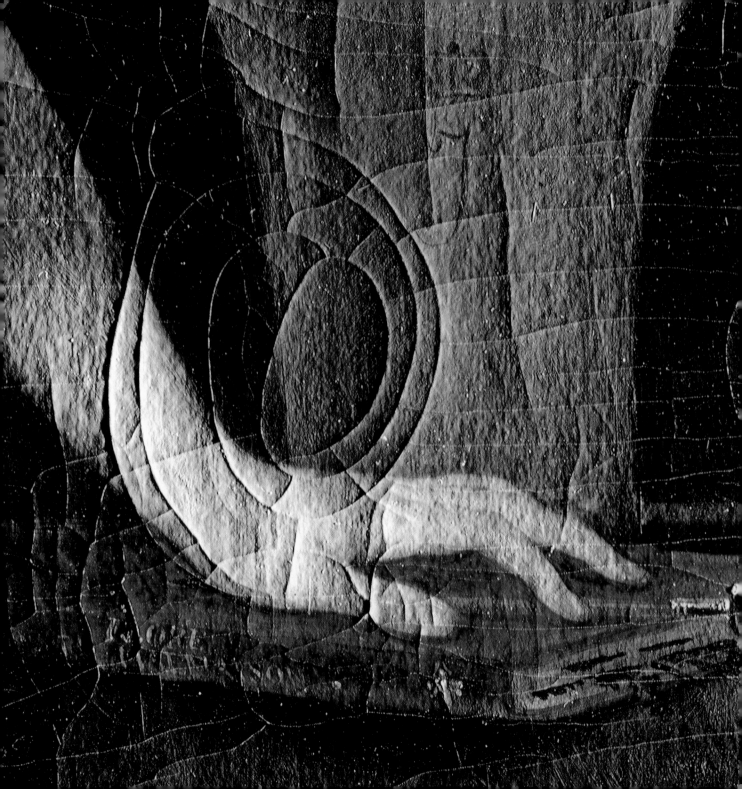

caused by changes of surroundings, dust, traces of tar, etc.

It should be possible to detect areas of wear, extra layers under the surface, anomalies, breaks in the consistency of a patch of colour, or the characteristics of a painting without even touching it (ill. 29). The craquelure should also be studied with a binocular glass under light set at different angles. We have already described how photomacrographs, the properties of which were discussed above, can disclose the state of preservation of the pigment and the pattern of the network of cracks, but a microscope can bring out the characteristics of the edges of the cracks, and sometimes the nature of the primer or ground can be seen between them. Microscopic examination of a number of paintings has shown that they were painted on primer which varied in colour from one area to another, e.g. several of Leonardo da Vinci's works. This is not a case of a coloured primer but of local colour, and it can be very useful to ascertain this.

The adherence of the gold leaf which forms the ground of some "primitive" paintings can be checked. The same process makes it possible to determine the extent of the gold ground, which does not always coincide with the design on the surface, since the gold forms a slight relief which is clearly visible under a binocular magnifying glass.

With the aid of a powerful microscope ($\times 100$) it is possible to distinguish the composition of the colour, i.e. to see the surface characteristics of the pigment, its grinding and its bulk. Colours were ground by hand in the painter's studio until the early nineteenth century. The size of the grains of pigment varies according to school, era and even studio. Details of grinding which may help to determine the age and origin of a painting must be recorded photographically.

Signatures

Microscopic examination is essential for verifying signatures; if the paint of the signature is touched or crossed by the web of cracking in the actual pigment of the painting it is probably contemporary with the work. If a slightly enlarged photomicrograph with a wide angle is taken of a Courbet signature, the body of the letter "C" will be seen in relief, in bright colour against the dark ground of the painting. Cracking affects the signature as well as the painting of the ground, and this proves that the signature is contemporary with the painting, but it does not necessarily mean that the picture is Courbet's work (ill. 29). If the paint used for the signature is not affected by the cracking, this does not always prove that it is false, but that it was done some time after the painting. However, it is an unfavourable sign which should lead to further examination by various types of radiation.

The microscope is indispensable for studying the surface of the pigment, and it can also be used to examine and evaluate information produced by

28
Surface lighting shows here the so-called "spider's web" network of cracks which is characteristic of eighteenth century canvas preparation. In other respects the picture is perfectly preserved. *Portrait of the Empress Josephine*, Gros (Musée Chéret, Nice).

microsamples. In many cases examination of the painting as a whole does not produce the desired results. Then spot analysis must be envisaged and

microsamples taken for this purpose. This process will be described later in this book, in the section dealing with methods of sampling.

29
This photograph enables one to trace the original line of this signature of Courbet's. The network of cracks crossing through each letter and not truncated by retouching proves that the signature was done at the same time as the painting.

30
Photomicrograph (80 × magnification) showing a canvas made of indigo-coloured silk on which Poussin painted *The Assumption of the Virgin* (Louvre, Paris).

41

DISCOVERING THE INVISIBLE

Popular interest in photographs of things which are invisible to the naked eye is equalled only by the scepticism they provoke. The discovery of X-rays by Roentgen in 1895, and of ultra-violet light by Wood in 1913 was the key to the invisible. It is difficult nowadays to imagine the exhilaration and excitement with which people responded to the potential of X-rays. From 1896 onwards, scientists in different countries vied with each other to produce one disturbing image after another; things which were hidden within opaque substances became visible, and wood looked as transparent as glass. Traditional beliefs were all challenged, and the public had scarcely got used to this kind of radiation when the indefatigable scientists produced yet another method of researching beyond the visible. In 1913, the American physicist Wood succeeded in constructing a screen which eliminated the rays of the visible spectrum and only let ultra-violet rays pass through. Having passed through the so-called Wood's screen, these rays have the effect of causing certain substances to emit fluorescence, and it soon became possible to use this for photography.

1 Ultra-violet fluorescence

This invisible ray is immediately adjacent to visible light; it has a shorter wavelength (400–100 nm), and has the property of causing fluorescence and phosphorescence in various substances. Fluorescence ceases with the irradiation but phosphorescence continues.

31
A picture taken by ultra-violet light of this fifteenth century Italian painting restores the coloured hue peculiar to these radiations and shows up, in the form of dark patches, those parts of the work that have been retouched.

The radiation source for both study with the naked eye and photography is a mercury vapour lamp with a Wood's glass (nickel oxide) filter. The properties of ultra-violet light are particularly useful when the state of preservation of a painting has to be ascertained. Surface anomalies can be seen directly by this kind of light (ill. 31).

Varnishes

Under ultra-violet light a painting with a smooth coat of old varnish looks milky but fairly transparent. Interference such as attempts to remove the varnish, local retouching and repairs can be clearly seen as darker patches (ills. 32, 33). If the painting shows no sign of alteration under an old, transparent varnish, this may be an indication that it is in good condition. Nevertheless, confirmation should be obtained by using X-rays or infra-red light, which bring out very early, thickly covered retouching which is not visible by ultra-violet light. Accumulations of old varnish usually produce a grey fluorescence which conceals the basic condition of the painting, but it is always a different colour from modern varnish.

Contemporary restorers are sometimes requested by certain dealers to use an extremely fluorescent varnish which is completely opaque to ultra-violet light. This cellulose acetate varnish is of very recent origin; it forms a slightly greenish-yellow opaque layer in ultra-violet light. This should alert the observer, as it is usually a sign of deliberate disguising of serious damage, and it calls for tests by more penetrating radiation such as X-rays or infra-red light to ascertain the extent of the restoration or faking.

On the other hand, if the surface of the painting is grey but transparent, as if it were covered with fine muslin, it may be assumed that there is no recent retouching.

32
The Ensign of Gersaint, Watteau (Verwaltung der Staatlichen Schlösser und Gärten, Berlin, Schloss Charlottenburg).

33
Studying this picture under ultra-violet light we can reconstruct the patient work of the painter who modified the shape of his painting. It was originally restricted by being submitted as an ensign, then was subsequently enlarged at the top using strips of canvas cut from the sides. The dark lines certify to these major changes carried out long ago.

Retouching

This can appear in a variety of forms – dark patches, large expanses or small spots (ills. 34–36). Old retouching is usually executed over the varnish. The restorer often deliberately omits to remove the varnish altogether. If varnish were completely removed it would be harder to detect retouching of the original colour.

Visual examination must be supplemented by a photographic record, since it is essential to combine direct but momentary observation with permanent evidence and to carry out a supplementary examination of the surface by alternative methods. Infra-red photographs supply additional information on retouching under the varnish, and X-rays make it

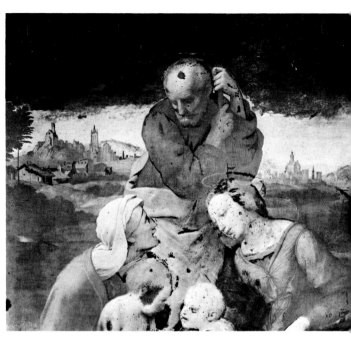

34
Holy Family of the House of Canigian, Raphael (Bayerische Staatsgemäldesammlungen, Alte Pinakothek, Munich). Group in direct lighting.

35
A photograph taken by ultra-violet light clearly shows the dark lines or patches where light touching-up has been done.

possible to ascertain the extent of radical alterations of the paint layer and compare surface restorations with the extent of defects in the picture.

Retouching can be clearly seen on sixteenth century paintings, which furnish an excellent example of the potential of ultra-violet fluorescence. The central part of the figure is in poor condition; the body is covered with patches which suggest advanced disintegration (ills. 37, 38). Luckily this is an exceptional case.

If suspect glazes and breaks in the craquelure in areas which look dark on the fluorescent photographs cannot be seen with a magnifying glass or

36
X-ray photography, which confirms the fine state of this picture, also shows up a major change which has taken place in it. In the top right and left hand corners two groups of angels can be seen which, nowadays – as the direct light photograph shows – are no longer visible.

37
Lucrezia, Flemish school (Musée des Beaux-Arts, Beaune, France).

38
Ultra-violet light shows up the dark patches on Lucrezia's body that prove considerable surface retouching.

46

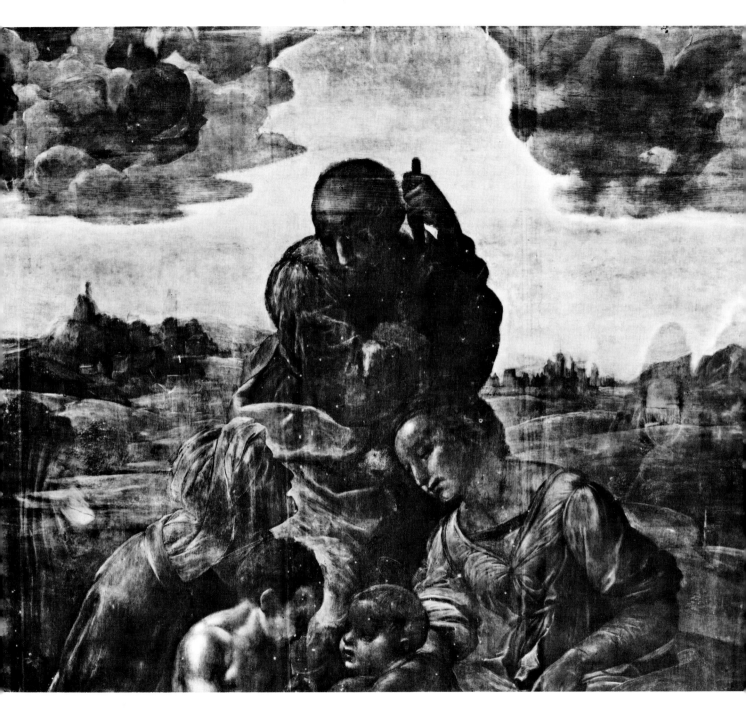

47

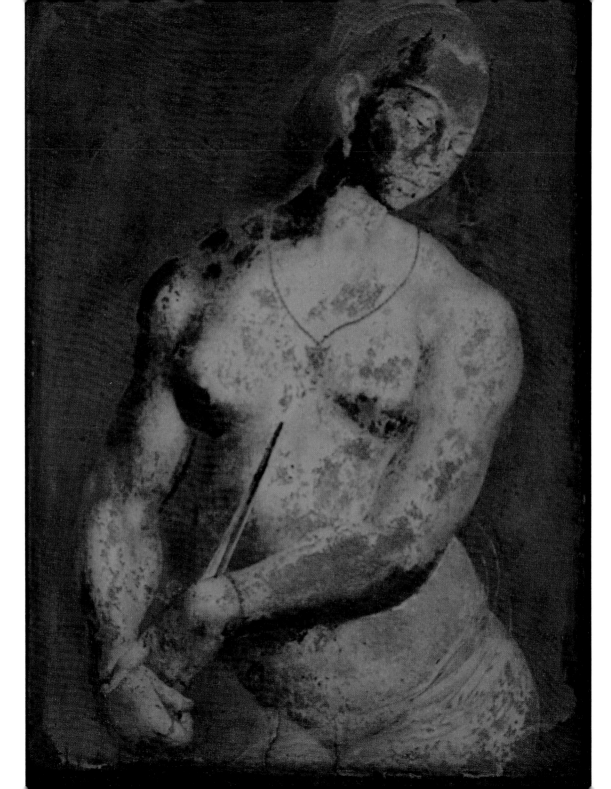

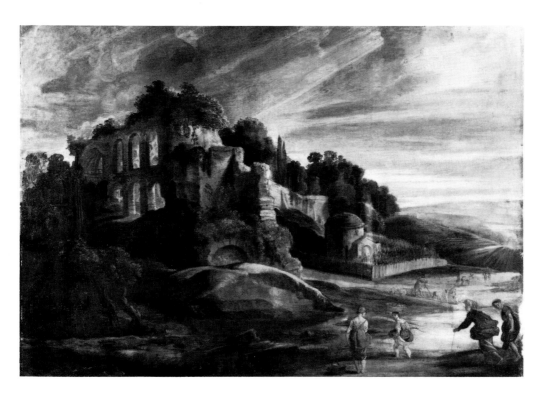

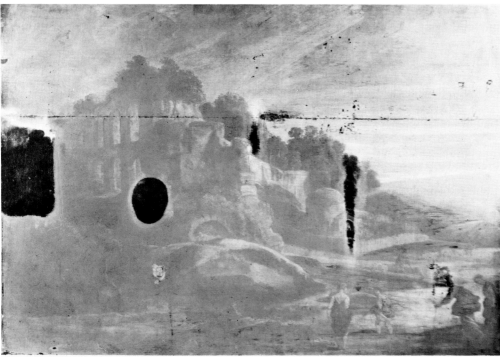

41
Venus at her Toilet, Titian (National Gallery of Art, Washington, D.C., from A.W. Mellon's collection). Photographed in direct light.

42
The infra-red picture brings out the delicacy of the glazes and the skill of the painter in modelling the drapings.

microscope, the possibility that the varnish has been removed must be considered. Indeed, ultra-violet light will show any attempt at partial removal of varnish as dark patches, which are sometimes very

39
Landscape and Castle Ruins, Rubens (Louvre, Paris).

40
This Flemish landscape masterpiece is intact. Ultra-violet photography clearly shows up devarnishing tests which should not be confused with retouching. The homogeneous quality of the material seen under the microscope confirms that we have here the result of exploratory work on the varnishes carried out by the restorer.

difficult to distinguish from retouching. Ultra-violet fluorescence photographs of Rubens's *Landscape and Castle Ruins* show a number of regularly shaped dark patches. This is not a case of retouching but of attempts to remove varnish, which must not be confused with alterations to the paint layer, this picture being in good condition (ills. 39, 40).

In cases where the painting has had the varnish removed (for example, some modern and Impressionist paintings), the advantages of ultra-violet light are less obvious. Since the areas of colour have the degree of fluorescence appropriate to each pig-

ment, dark patches are hard to distinguish from possible retouching. However, attention should be paid to breaks in the homogeneity of any colour and to the fluorescence of the whites used by each artist. Lead and silver white have been used from time immemorial, and produce a dark tone which is very different from that of zinc white, which was discovered in 1780. This produces a highly luminous yellow-green fluorescence.

The ageing of colours must be taken into account during an ultra-violet examination, since similar pigments ground in the same binding agent will change appearances according to the date at which they were used. Fluorescence photographs on colour film will detect their overall use and can speed up the examination. When a painting is studied with the naked eye, its appearance can be recorded on this type of film.

Fluorescence photographs indicate not only occurrences such as revarnishing, major restoration and filled-in cracks but also inscriptions which have been painted over, or retouching on partially obliterated signatures or inscriptions. Interpretations of the reactions of various pigments may be disputed, but it is quite obvious that the coherence of a signature and its homogeneous appearance under ultra-violet light will always be a valid criterion. The same is true of inscriptions, both on the painting and on the wood or canvas support, or even on the frame.

This illustrates the importance of ultra-violet photography. It enables us to form an opinion of the state of preservation of a painting. In some cases retouching is seen to be extensive even when there is little change in the general appearance of the picture. In many cases the restorer has had trouble in matching

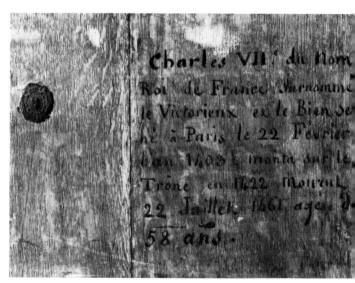

43, 44, 45
The *Portrait of Charles VII* by Fouquet (Louvre, Paris) has an inscription on the back which has been partially obliterated with time. The infra-red picture, however, reveals clearly a moving text evocative of the help given to the king by Joan of Arc.

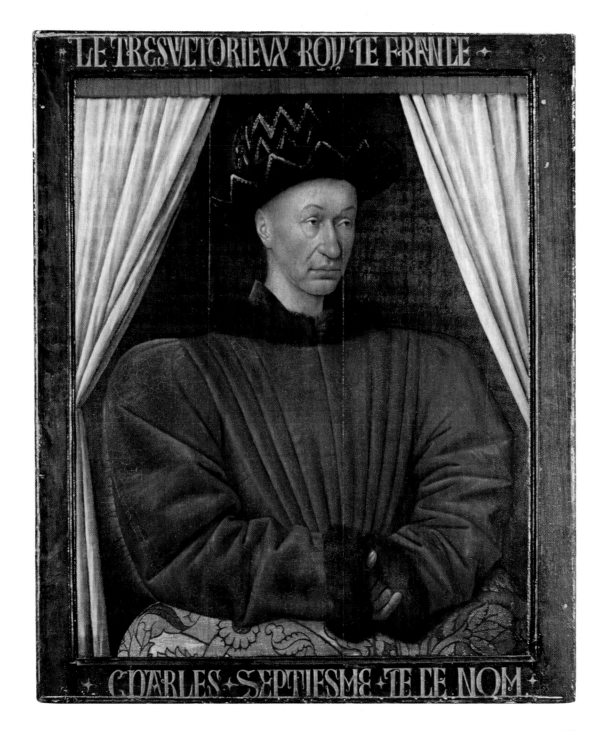

Peint Par
Le Chevalier Ernou
1721.

his pigment to a local colour and has elected to repaint a considerable part of the picture. The exact extent of these radical alterations can be ascertained by comparing an X-ray with an ultra-violet photograph. Earlier over-zealous restoration can be remedied, for nowadays the restorer's chief aim is fidelity to the original; he respects the creative artist's work and regards his own job as being the prolongation of the painting's life by appropriate

46 and 47
This carefully disguised inscription, in which only the date is still visible, is on the back of an eighteenth century portrait of the English school. Infra-red radiation however enables us to decipher the inscription and identify the hitherto anonymous painter of the picture. (Musée des Beaux-Arts, Carcassonne, France).

48 and 49
Study of a seated man by Gros (Musée des Beaux-Arts, Caen, France). This hitherto unsuspected picture came to light under infra-red radiation.

treatment, the removal of the majority of old repairs and restorations, and the detection of damage. One of the modern restorer's primary objectives is to remove as many as possible of the additions the painting has accumulated over the years, as well as to carry out safety measures. A picture on which the course of varnish removal can be traced is obtained when, instead of using the ultra-violet fluorescence described above, a painting is photographed by near-ultra-violet light – i.e. lighted with low-voltage mercury vapour lamps without a filter,

and using a camera fitted with a filter which allows only near-ultra-violet rays to pass through. This process brings out the smallest traces of surviving varnish. However, it is not as accurate as examination and photography by ultra-violet fluorescence. This is why it is not as widely used.

2 Infra-red rays

Infra-red rays are situated close to visible light but cannot be seen with the naked eye. They make use of photographic techniques to record effects which extend the power of human vision.

In 1800 Sir William Herschel, examining a solar spectrum broken up by a prism with the aid of a thermometer, suddenly noticed a rise in temperature when he moved from the violet to the blue band but, even more surprisingly, this became progressively more marked beyond the visible red band up to the point where the effect on the thermometer began to decrease.

This proved the existence of the invisible warm rays already postulated by the ancient scholar Lucretius

50
Suzanna and the Elders, sixteenth century Flemish school (Musée des Beaux-Arts et d'Archéologie, Rennes, France).

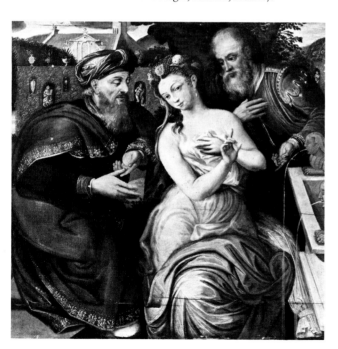

51
The preliminary drawing carefully executed under this painting is seen again under infra-red rays that reconstruct the artist's meticulous workmanship.

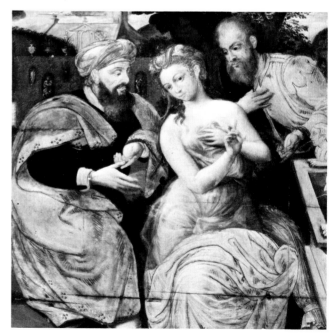

in his *De Rerum Natura*. These rays extend from visible light to the Hertzian waves of 800 to 10^5 nm, but they can only be utilized in the infra-red zone nearest to visible light. Some substances are more or less transparent to infra-red rays, so that they make it possible to examine elements which are normally invisible. Infra-red photographs can lift the veil of time and penetrate the varnish and glazes, enabling us to study the picture underneath the surface and sometimes to detect stages in the composition which are normally invisible.

For many years infra-red photography was confined to laboratory use, but it can easily be mastered by collector and technician alike; with a few exceptions, which will be listed in the technical notes, an ordinary camera is used, but the process calls for a good deal of practical knowledge and a number of careful precautions.

Varnishes

Paintings are covered with varnish to protect them and avoid damage to the paint layer. Varnishes can vary greatly in quality, and are sometimes deliberately tinted. From a very early date, well before the Renaissance, the Italians knew of something they called *velatura*, which was simply a coloured varnish used to thin out parts of the painting or to emphasize a shadow or detail.

Under the influence of nineteenth century Romanticism, restorers used to apply coloured varnish to paintings so as to give them a dark golden tone. When varnishes age they form an opaque layer which obscures essential details of the painting. It

52
The Betrothal of the Arnolfini, Van Eyck (National Gallery, London).

must also be remembered that as colourless varnishes age their refractive index changes, and that the resins of which they are composed may also

57

deteriorate and turn yellow. For this reason it is advisable to take an infra-red photograph before removing varnish; it will bring out details in the opaque parts of the painting.

Surface retouching over the varnish can be seen by ultra-violet light, but problems underneath the surface can be detected by infra-red photography (ills. 41, 42). These rays make it possible to see how a work looked before it was completed, by virtue of the varying power of absorption of the different coloured varnishes.

Signatures

Over the years, many inscriptions are covered up, either accidentally by successive layers of varnish or deliberately by glazes, in order to substitute more impressive attributions. In both cases infra-red rays are absorbed or reflected by the surface layers and provide a photograph which can be read more easily. Signatures which have been painted over, altered or covered up become visible again, and this process also makes it possible to decipher obliterated labels and inscriptions painted on the back of the canvas or the frame (ills. 43–45). One of the chief merits of this type of radiation is that the researcher can use it to decipher inscriptions and

ascertain the extent of restorations which may, in fact, turn out to be overpaintings. For instance, Carpaccio's signature was discovered on a painting in the Metropolitan Museum of Art, New York, which had previously been attributed to Mantegna. Infra-red rays also revealed an inscription covered with black glaze on the back of an eighteenth century painting by the Chevalier Ernou. The creator of the picture was thus rediscovered and the inscription is now visible (ills. 46, 47).

This process of infra-red photography can also be applied to archive documents and drawings. An infra-red photograph of an illegible piece of paper revealed a fine academic composition by Gros which had previously been unknown (ills. 48, 49).

Pigments

There are numerous pigments which, in combination with a binding agent, form the substance of a painting. Most of them are mineral or organic in origin. Such colours comprised the palette of earlier painters and have been the subject of a great deal of physico-chemical research. New pigments were invented in the nineteenth century; their presence can provide a clue to the painting's date. It is important to be able to identify them and differentiate them from natural pigments without having recourse to chemical analysis, which necessitates removing a sample.

Infra-red photography makes it possible to identify certain pigments. For example, if various blues applied close to each other are examined and photographed by natural light, the resulting print will

53
This infra-red photograph successfully reinstates Van Eyck's original drawing, his first attempts at light and shade in the subject's clothing and his search for the right shape for the hand. His first sketch showed a more open one which is as elegant and expressive as the hand we now see.

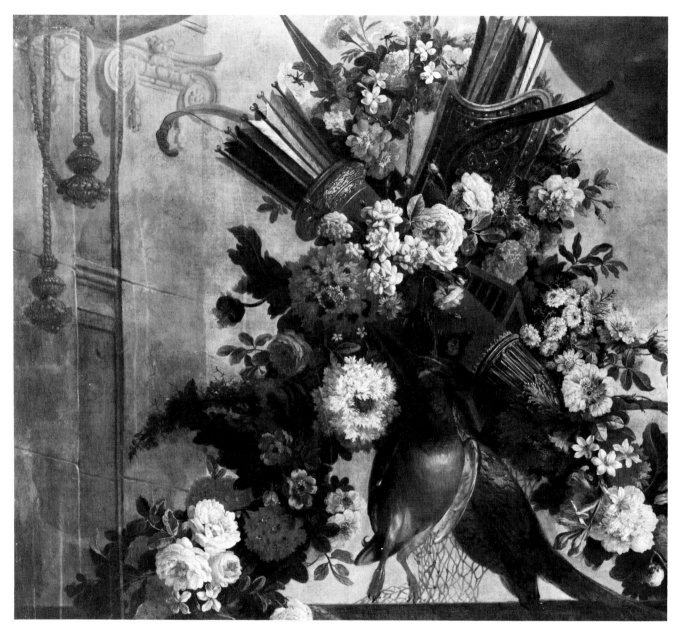

54 and 55
This fine work by Belin de Fontenay, *Flowers, Hunting Trophies and Game* (Louvre, Paris) is painted over another picture, part of which – the seated man on the left – reappears because of the power of absorption of the infra-red rays which also enable us to appreciate better the artist's draughtsmanship.

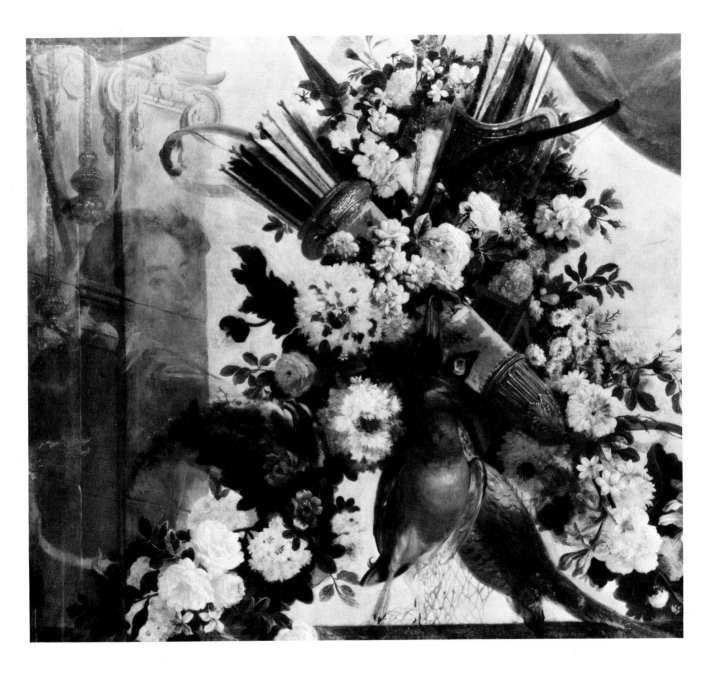

61

show very little difference in the tones; on an infra-red photograph, however, cobalt blue will be colourless and different from the other pigments. This is a simple test. There are tables of the reactions of various pigments to infra-red radiation. These reactions appear as values, not colours, since infra-red photography takes place beyond the visible spectrum.

Infra-red rays supplement examination by ultra-violet light; but the diagnosis supplied by infra-red photographs should be confirmed by an X-ray examination.

Infra-red rays are especially useful for studying the painter's technique. They penetrate the outer layers of the paint, especially the browns and yellows, and produce a photograph which shows the unfinished painting in the course of construction (ills. 50, 51). It is obvious that the value of the photograph will be proportionate to the power of reflection and absorption of the pigments. The results will vary considerably from one painting to another, some colours looking more transparent than others; the photograph obtained must always be compared with the painting. Sometimes infra-red radiation will only produce a slightly sharper image than normal light, the outlines being very little altered by the varnish, but usually the sketch and any retouching or alteration will appear. Infra-red studies of Van Eyck's *The Betrothal of the Arnolfini* in the National Gallery, London, showed repainting carried out by the artist. The figure's left hand was originally in a slightly different positon. This discovery was made possible by the fact that the Flemish master used very light glazes (ills. 52, 53). The same process showed traces of clothing on Jean Fouquet's fine diptych, *Etienne Chevalier* in West

Berlin which were slightly different from the finished work.

With masters such as Rembrandt, who used a lot of browns and yellows, it has been possible to obtain remarkable photographs of their work, revealing the intermediate stage between the sketch and the finished painting.

Research into the Holbein portraits in the Basle Museum detected a good deal of the original drawing. It is unusual to get such spectacular results, but a good example of the penetrating power of infra-red rays is provided by the photograph of Belin de Fontenay's seventeenth century decorative composition. The figure of a man appeared underneath a bouquet of flowers; it was the preliminary sketch for a painting which had been invisible for hundreds of years, and can now be seen again (ills. 54, 55).

Infra-red reflectography

Ordinary infra-red photography ceases at the wavelength of 900 nm. At this point some colours (e.g. greens) always look black on the print.

Since transparency increases in proportion to the wavelength, scientists have been trying to push the 900 nm limit back to 2000 nm (2/μ) by using special sulphur lead detectors and quartz lamps. This equipment produces an infra-red picture through the medium of a camera like a television camera, the resulting reflectograms being examined on a screen. Remarkably clear reflectograms have been obtained. This method has been successfully applied to the study of Flemish Primitives, where drawings by the painter have been found under the paint.

3 X-rays or Roentgen rays

Visible light, infra-red, ultra-violet and gamma rays are all, as we have noted, electromagnetic. X-rays are also electromagnetic but they do not spread at the same speed and are only differentiated by their wavelength.

X-rays are unquestionably the most useful means of studying works of art and checking their condition. They lie between ultra-violet and gamma rays on the electromagnetic scale, without any precise point separating them from the groups of rays on either side. Since their discovery in 1895 by the German physicist Roentgen, the rays which bear his name – though they are usually called X-rays – have been sporadically applied to the study of painting in France and Germany. Shortly after Roentgen's discovery, X-rays were first applied to the study of painting at the University of Munich. Professor Faber of Weimar and then Professor Koenig of Frankfurt-am-Main and Dr. Wolters continued X-ray research, which was simultaneously pursued in France from 1914 onwards by Professors Ledoux-Lebart and Goulimart and continued by Dr. Chéron after World War I. In Switzerland Dr. Gilbert worked on the same subject.

During subsequent years the use of radiography became widespread. Laboratories equipped with X-ray tubes were set up in the major museums of the

56
Using a luminous cross, the machine operator centres the X-ray emission tube on the area of the picture to be photographed.

57
Film, in a paper envelope, is attached to the back of the canvas, making sure that it is firmly in place.

world – the Louvre, the Fogg Art Museum at Harvard and the Naples Museum acquired them in 1926 – and a number of researchers embarked on the study of the resulting photographs. Among the most distinguished were de Wild, Wolters, Laurie, Burroughs, Mancia, Gilbert and Vergnet-Ruiz.

For photographing paintings, soft rays emitted with an exposure of the order of 20–60 kV and 4–6 mA (weak intensity) are generally used. The quality of the result varies according to a number of specific factors (ills. 56, 57). Great care must be taken that the film is in close contact with the picture surface. Furthermore, if the X-ray film is to be of any use, the conditions under which it was taken must be recorded so as only to compare like with like. It is desirable to assemble a series of films of pictures by the same master or from the same period or school, taking care to include only absolutely authentic paintings photographed under identical conditions as works of reference.

X-rays can penetrate thick layers of substances which are opaque to light. The opacity of a substance increases with the atomic weight of its components. A substance with a high atomic weight absorbs X-rays better than one with a low atomic weight. When a painting executed chiefly in lead-based colours is radiographed, a film is obtained with areas of light which vary according to the thickness of the pigment layer, depending on the distribution of the heavy elements over the painting, since these colours have a high atomic weight. When we radiograph a painting carried out exclusively in organic or earth colours which are transparent to X-rays, the images on the film will not show much contrast since these colours absorb very little radiation.

58
Etienne Chevalier, Fouquet (Staatliche Museen Preussischer Kulturbesitz, Gemäldegalerie, West Berlin).

59
X-ray photography of the portrait of Etienne Chevalier brings out the quality of the painting carried out with colours of high atomic weight. It shows the revisions made by the artist in order to adjust the size of the head to the subject's body. The large cross pattern is due to the wooden battens (the cradle) fixed behind the panel.

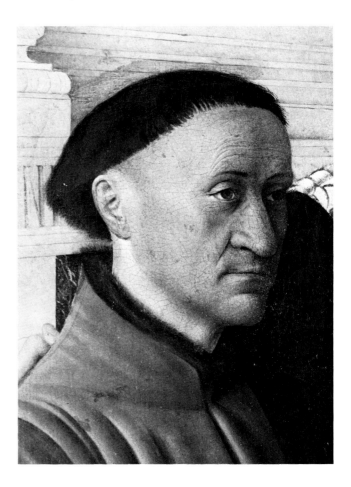

A painting is made up of three elements: the support, the ground and the skin of paint. The information to be obtained from an X-ray film will depend on the ability of these three elements to transmit radiation. It is obvious that if any one of them is an insuperable barrier to radiation, there will be no possibility of obtaining a decipherable radiographic image. However, if they are all permeable by X-rays, with clearly defined differences in density, the film will throw considerable light on both the history of the painting and the problem of its conservation. It should always be remembered that radiography is only an assistant to diagnosis. The films are very difficult to interpret, each painting being different from the last and the total power of transmission varying with each element. X-ray film of one painting differs from another as much as photographs of one person differ from those of another.

X-ray film shows an aspect of a picture which cannot normally be seen. If a sketch was executed in colours of a much higher density than those of the surface layer, as in much of Rembrandt's work, the first stage of the painting will be visible on the film. In some cases there will be a complex image made up of the sketch and the successive layers, which can produce a strange effect (ills. 58, 59). The series of faces painted by Le Sueur in *The Muses* are reflections of transient moments of creative inspiration. The X-ray film does not show the first stage alone, but a composite picture of the first and second. A

60
Radiography shows up the state of a wood panel completely infested by parasitic insects that have gouged out deep channels.

figure appears in profile and full face at one and the same time. X-ray film is not entirely selective; it does not produce a complete reconstruction of any one stage of the work. But if the painting was executed lightly in low-density colours and then over-painted extensively with clear colours, a first sketch in pigments with low atomic weight will not be visible although it actually exists.

The support

Extremely accurate information can be obtained from X-ray films in the study of supports.

The wood, canvas or metal which holds the paint layer is known as the support. In the case of a painting on copper, which is rare, X-rays are no use since the radiation of the strength used for studying paintings cannot penetrate metal. If more penetrating rays are used, they will not provide any information about the paint layer because its density is lower than that of the support. Information about paintings on metal can only be obtained by studying the surface with infra-red or ultra-violet light.

In the case of paintings on wood, which includes most pictures executed before the seventeenth century, it is very useful to be able to study the structure and behaviour of the panel. Examination with the naked eye is often difficult if not impossible, because the surface of the wood is often covered with a layer of ground applied by the painter to protect it from the effects of abrupt changes in humidity. This ground is composed of a mixture of colours, which may sometimes be marbled, and is usually permeable by X-rays. It is therefore possible

to obtain an X-ray film of the hidden panel and to form an opinion of its condition. If the original support has not been painted over, it is often damaged – there may be worm holes or warping and shifting of the boards – and this used to be counteracted by the type of reinforcement known as a cradle. This is usually composed of vertical struts applied to the panel, which is sometimes reduced in thickness or covered with a backing. In the latter case the original panel cannot be studied because it is hidden under several millimetres of board. Here again, X-rays can help to identify the nature and condition of the wood, which may vary according to the geo-

61
X-ray emission equipment; the stratigraph, specially modified for studying painted panels on wood either reversible or inlaid.

graphical origin of the painting, by revealing the structure of the panel.

Pictures painted on thick panels of softwood are often attacked by parasites such as woodworm, lyctus, etc. These insects make channels inside the wood, the extent of which can be detected by X-rays. It should be noted that these channels can appear on the film as various shades of grey and white (ill. 60). X-rays make it possible to follow the effects of treatment; if a second film is taken several months or years after the first under the same conditions, and one is laid on top of the other, it will be possible to check the size of the channels to see if they have grown in volume or reached the essential parts of the painting. X-rays are therefore a means of checking the condition of the support.

X-rays of pictures on wood panels where both sides are painted raise specific problems. Since the usual procedures produce a confused image made up of the support, the painted surfaces and the cradle with their varying densities, it is preferable to use a stratigraphical technique which eliminates nearly all the elements at the back of the painting. This method calls for specialized equipment (ill. 61).

X-rays also reveal the consolidation and assembly methods which were in use from the thirteenth to the sixteenth centuries. Bands of thick threads were embedded in the ground to prevent the joints in the boards being visible on the paint layer, and these can be seen on the film. Ground-up hemp can also be seen on film of a number of fourteenth century paintings. Muslin was sometimes embedded in the ground to make it adhere better, and this, as well as knots in the wood, mastic and joints, can be detected.

Most paintings were executed on canvas after the seventeenth century. In the nineteenth century many of them were relined, that is, an extra reinforcing canvas was attached to the back, and this makes it impossible to see the original support.

The relining canvas is not impregnated with the white ground, and is therefore not dense enough to obscure the original canvas, which is visible on X-ray film. If the painting has been transferred – removed from its original support – traces of the former support, the imprint of which remains on the ground, can be seen. The presence of a sheet of muslin can indicate an earlier transfer.

The nature of a canvas will vary according to the time and place of its manufacture. Venetian canvases, for example, are often damasked or woven in chevrons, while Rembrandt used plain canvas or occasionally canvases with a herringbone weave. An X-ray film makes it possible to distinguish the characteristics of the original support (ill. 62).

X-rays reveal not only the nature of the canvas but any extensions made to it for decorative purposes (e.g. to make a picture fit a location or frame for which it is too narrow), or for commercial reasons. In both cases the X-ray film enables us to ascertain the extent of the alteration; bands may have been attached to the sides or sections may have been cut off, or pieces of canvas from various old paintings may have been attached to wood to include some authentic areas in a forger's work.

62

X-ray of a picture painted on canvas with low-density materials. The photograph shows the characteristics of the backing (fineness of weave), a vertical cut, folds which have led to the painted layer being broken and a serious area of damage to the left.

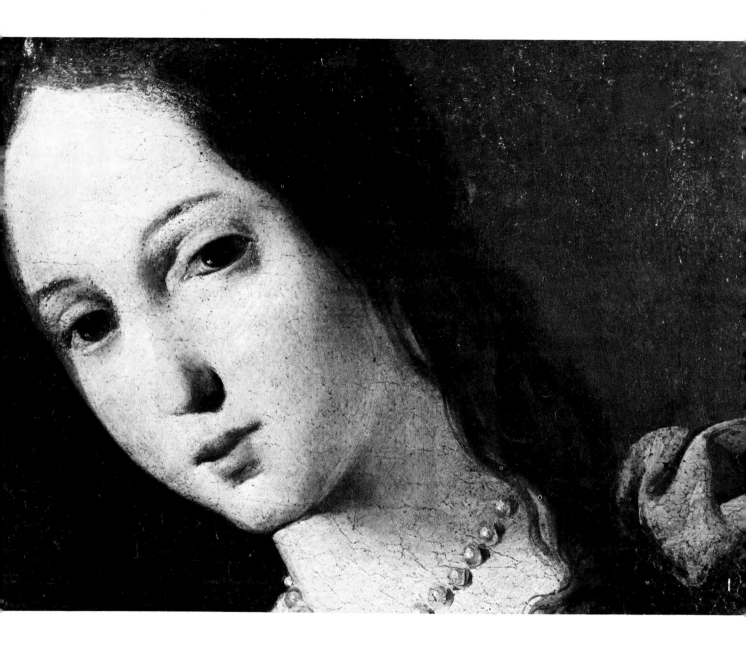

63
Saint Agatha, Zurbaran (Musée Fabre, Montpellier, France).

64
Lack of paint on the right of the picture, as well as Zurbaran's style and modifications, are shown up by this X-ray plate.

The paint layer

X-ray studies make it possible to ascertain the state of the pigment layer. Obvious changes in density, and too-light or too-dark areas with shapes which are at variance with the subject of the painting, indicate some kind of interference – retouching, mastic, patching and so on. By comparing the surface or an ultra-violet or infra-red photograph showing the area of superficial retouching with an X-ray film showing gaps in the original painting, it is possible to find out whether the retouching fills the missing parts exactly or whether the restorer has painted outside the edges of the gap. It should be noted that the X-ray film can show gaps in the painting as either white or black. If the gaps have simply been covered with a low-density colour, they will look dark and the texture of the canvas or wood support will show clearly through, but if the gaps have been filled with high-density mastic, it will not allow the rays to pass through and a white patch of the exact size will appear. Worn places will also appear, as areas where the canvas shows particularly clearly in comparison with the rest of the painting.

Before embarking on restoration, the extent of any damage hidden under the surface must be ascertained in order to plan the appropriate treatment to correct it. X-rays can be used for this. The appearance of the craquelure on the film should not be overlooked since its clarity indicates the quality of the radiograph. It is a good test of the contact between the film and the paint layer, which must be close if a valid record is to be obtained.

The importance of radiography in checking the condition of a painting has been emphasized, and it is equally valuable in the study of the stages in which paintings are built up, from the viewpoint of both art history and the painter's technique. The composition will not be visible unless the ground between the support and the paint layer is permeable by radiation. We have seen that most supports, be they wood or canvas, are penetrated by X-rays except when the back has been coated with a ground.

Grounds generally consist of more or less fine plaster mixed with gum and calcium sulphate, and are permeable by X-rays. This is not true of white lead grounds, which were used in the nineteenth century, but forgers are often unaware of this property, and use it. A completely opaque support should be a danger signal to the art historian or collector.

It should be remembered that white paint, which is an important element in many painters' palettes, consists of heavy metal salts. White lead, also known as silver lead, was used by earlier painters and is opaque to X-rays. Earth colours and blacks, on the contrary, have very low atomic weights. Between the two extremes come colours with powers of absorbing X-rays which vary according to their atomic weights. The variations in their density produce the different shades on the X-ray film. When the sketch is basically executed in white with a mixture of earth colours (the usual practice of the old masters, particularly Rembrandt), very informative X-ray films can be obtained of stages in the painting which are covered with glazes and no longer visible to the naked eye. The whites stop the X-rays and reveal a picture which is often radically different from the finished work (ills. 63, 64). They

65
Mona Lisa, Leonardo da Vinci (Louvre, Paris).

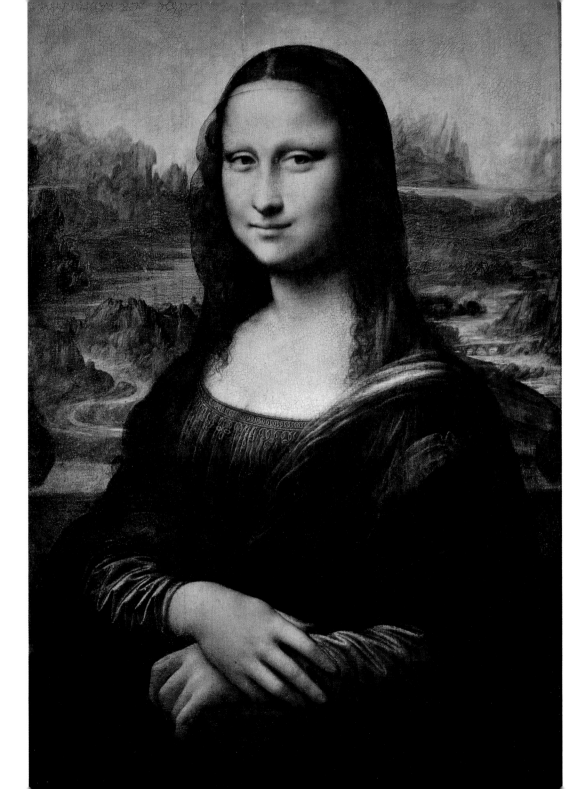

revive the first touches of the painter's brush. The image on the film can be almost as informative as a sketch or wash drawing.

When the sketch has been executed in low-density colours it is not visible. Only the general construction of the work will then be seen. In some cases there is very little contrast visible on the film because the painting was carried out entirely in low-density glazes. This is true of much of Leonardo da Vinci's work, notably the *Mona Lisa,* (ills. 65, 66). Most painters use a technique somewhere between the two extremes. X-ray films of these paintings look as if the painter has continually altered his work, repainting some parts so that when they are finished they look completely different from the early stages revealed by the film (ills. 67, 68). There are many types of these retouchings. Between the thirteenth and sixteenth centuries, painters made detailed studies of the composition before executing their work; this is why there is very little difference between the sketch and the finished picture, especially with the Primitives. These painters, however, worked with low-density colours and there is usually very little contrast to be seen on the X-rays. Alterations are commoner among painters who allowed themselves to be guided by the inspiration of the moment. X-ray films revealed that the pose of the model for Rembrandt's *Bathsheba* had been altered. The figure has two heads painted one after the other by the master. X-rays thus restored a lost stage in the creation of the masterpiece.

Sometimes the face is perfectly clear, but the expression is different in the finished work. This was true of Manet's *Olympia,* the coarseness and realism of which are clear on an X-ray film, revealing an early psychological stage which is not to be seen on the finished work (ills. 69, 70). One of the great virtues of X-rays is that they expose not only the state of preservation of a painting but the hesitations and changes of mind of the master in the course of building up his work. Rembrandt's *Portrait of a Young Man* is one of the best-known examples of this. The Dutch master's handling of a large brush in his later years was clarified, and in addition a forgotten composition, a Virgin bending over a cradle, became visible. The painter had covered it with the portrait of his only son Titus, whom he was to outlive (ill. 71). This discovery was confirmed by spot analysis detailing the stratigraphy of the pigments (ill. 72).

However, the use of X-rays should not be confined to tracing the early history of the painting; they are particularly valuable in the study of the painter's style.

If all the X-ray films of paintings by an artist show a predilection for particular colours, the same choice of brushes and consistent handling of the paint, it should be possible, after studying the whole corpus

66
X-ray photography of this mysterious picture confirms the excellent state of the work. It has undergone neither retouching nor repair work, and illustrates well Leonardo's technical subtlety.

67
Detail from *The Martyrdom of St. Matthew,* Caravaggio (San Luigi dei Francesi, Rome).

68
Radiography of the right-hand part of the picture shows up an original, and very different, version of the picture we know today.

69
Olympia, Manet (Louvre, Paris).

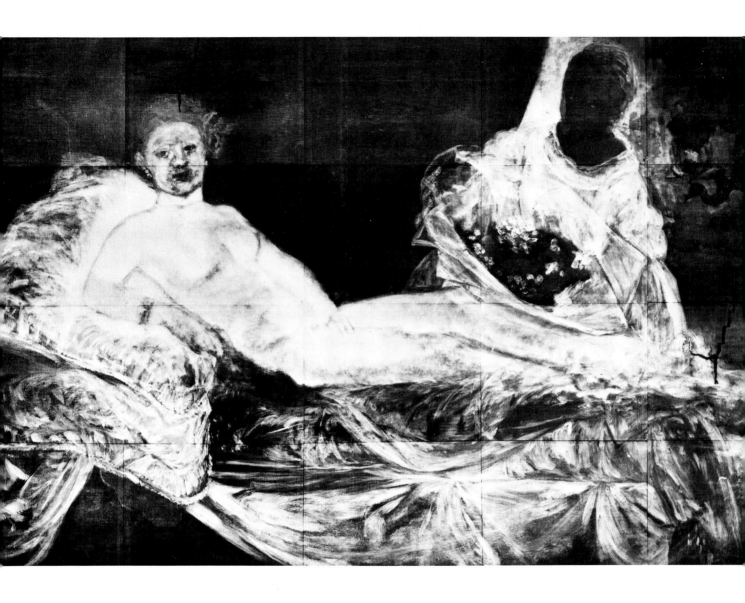

70
Olympia's face, under X-ray, seems realistic in treatment, with a heavy nose and square face. Comparing this with the one we can see shows how harmoniously the artist has worked these elements into the finished picture.

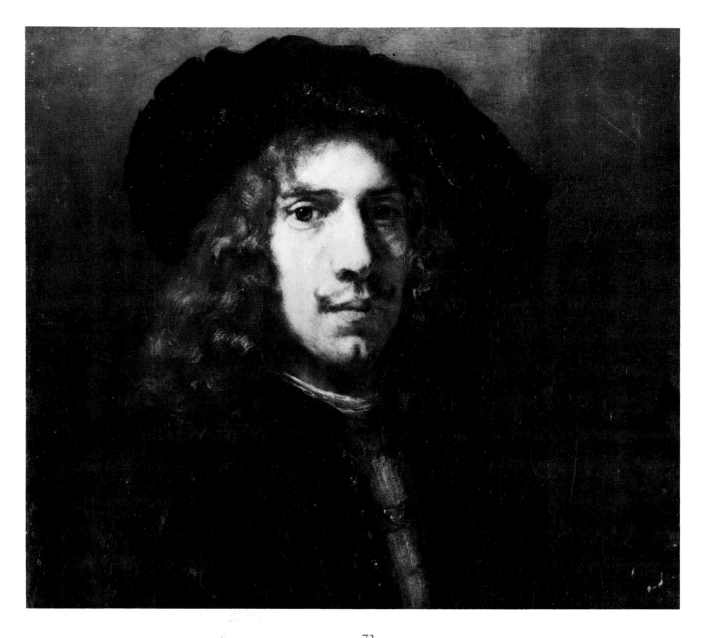

71
Portrait of a Young Man, Rembrandt (Louvre, Paris).

72
X-ray photography shows the existence, under the painting we normally see, of a sketch for another Rembrandt picture: a woman leaning over a cradle.

80

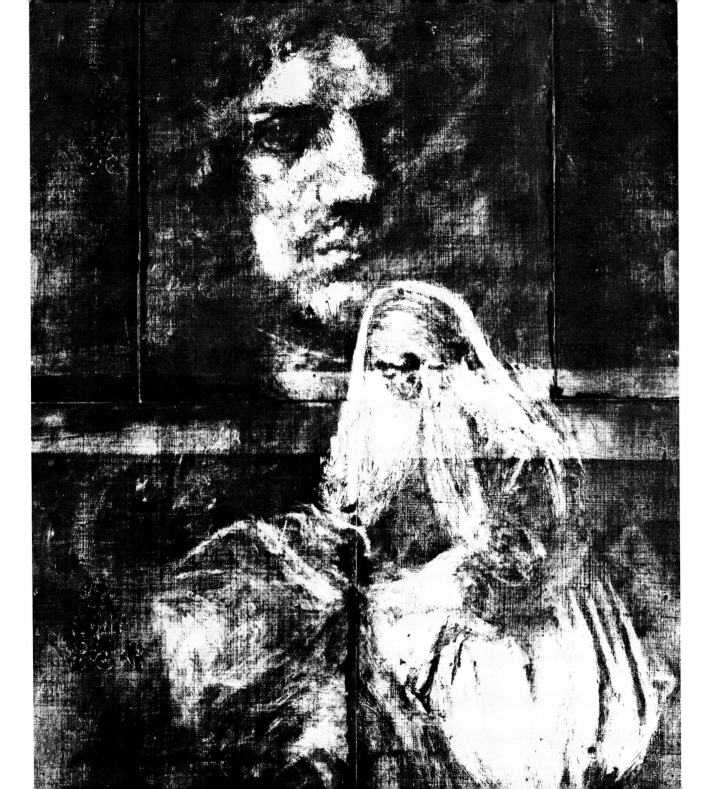

of his work, to correct mistaken attributions, improve chronological catalogues and differentiate between a copy and the original. The copyist or forger is only interested in reproducing the superficial appearance of the master work, so X-rays will bring out the differences – and they are profound – between the first version, the master's sketch, and that of his imitator, provided that there are enough films of authentic paintings available for comparison. These films of undisputed masterpieces can be used to draw up a scientific catalogue, so long as one bears in mind that the X-ray film results from the selective power of the radiation; the observer must always take this into account when trying to interpret the film.

X-rays expose images which predate the visible painting by penetrating the pigment, and by using them we can sometimes turn back the clock. For example, X-ray film of a Caravaggio painting detected an earlier composition. In such cases the painter's experiments, various stages in the work of creation, and rejected compositions become perceptible, along with changes in the physical and aesthetic structure of the picture. X-rays are the art historian's best friend (ills. 67, 68).

The photographic and radiographic processes described above are relatively simple and well-established. We shall now go on to more complex methods. which are still in an experimental stage.

ANALYTIC METHODS

SIMPLE TECHNIQUES

The processes described above all have the advantage of being non-destructive. Spot analysis makes it possible to study the stratigraphy of a painting and the structure of the materials of which it is composed, but calls for microsampling. This type of sampling should only be carried out when it is absolutely unavoidable. It can be done if the painting shows signs of peeling or any other kind of damage because it does not do any additional harm. Once decided on, it is obviously carried out with the utmost respect for the work of art, and is nearly always invisible.

Microsampling

Samples are taken from a painting in order to study the structure of the materials and identify their components – pigments and binding agent. Sampling must not be done in such a way as to show on the surface of the painting. It is therefore essential to keep the sample as small as possible. It should never be bigger than a pin-head. The operation is done with the point of a lancet, using the existing network of craquelure to keep control of the detached fragment as far as possible. It can also be done with a hypodermic needle, which should preferably be sawn-off (ill. 73). The sample should include part of the ground, the paint layer and the varnishes. The wood or canvas support should be studied by some other method.

The number of samples to be taken and their location on the painting depend on the problem to be solved. The sample must be as small as possible, but must be truly representative of a colour or part of a painting. The facts furnished by the sample can be extrapolated to the whole area of the same colour if care has been taken to examine the repainted and restored sections by ultra-violet and infra-red radiation.

Samples should, whenever possible, be confined to the edges of the painting. Its size and condition should also be taken into account in the decision whether or not to take a sample. It is easier to carry

out this operation on a big, damaged painting than on a small one in good condition. In the latter case it is highly inadvisable (ill. 74).

The sample is embedded in a small quantity of transparent plastic which hardens as it cools. The plastic is then ground away until the edge of the sample is exposed. The flat side of the plastic where the sample comes through is carefully polished so that the sample can be studied under a microscope. The technical characteristics of the painting can then be seen; the section shows the number and colour of layers, the order in which they were applied, their thickness, details of the pigment grinding, and how evenly the pigments are spread (ill. 75). This elucidates the extent of any damage to the paint layer, the depth of the craquelure and sometimes the presence of splits or of layers of varnish under the surface of the paint. Sample analysis, however, is especially useful in the study of old retouching and restorations. Samples make it possible to distinguish between the original painting and any later retouching. The technical stages in which the work was built up, the characteristics of the binding agent, the successive glazes and even a painted-over composition located by X-rays can be seen in a series of layers on a photomicrograph, like the stratification of a geological section of rich alluvial land. The sample can thus confirm a discovery made in general examination. This was true of Rembrandt's *Portrait of a Young Man* (ill. 71). X-ray examination showed that there was another composition underneath the painting exhibited in the Louvre – a veiled woman bending over a cradle (ill. 72). While the painting was being restored, a

73
Taking a sample of the painted material in a picture involves using a hypodermic needle. The sample is approximately 0.5 mm².

74
Photomicrograph of a section (80× magnification) taken from a sample from the painted material of Titian's *Christ Crowned with Thorns* (Louvre, Paris). This shows how deeply the bitumen has penetrated the cracks and how the painted layer has lifted up as a result of the instability of the substance.

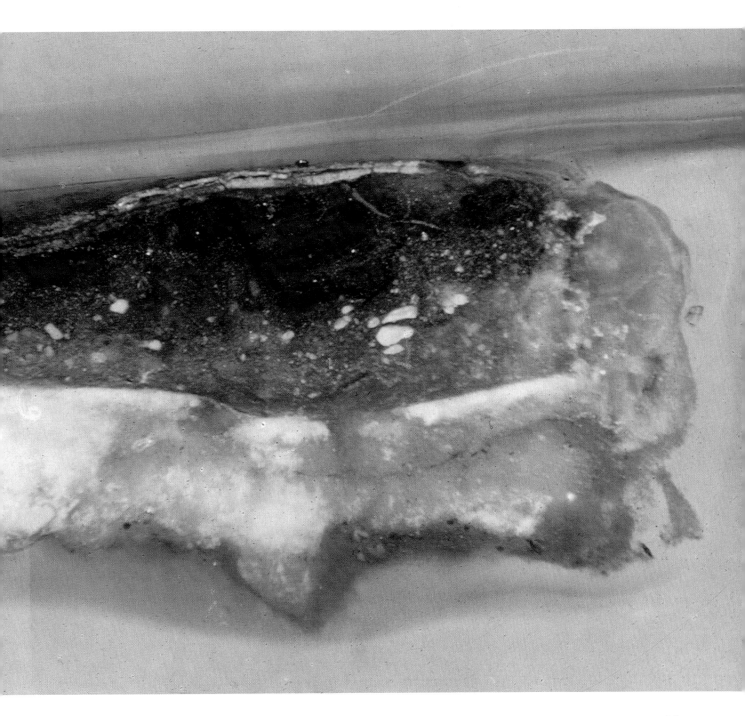

85

75
Procedure for preparing a section after obtaining a micro-sample.

microsample was taken from the middle, and it confirmed that there were two pictures, one on top of the other (ill. 76). It also made it clear that the picture underneath had been completed and varnished, since there were traces of varnish still visible between the white layer of the woman's veil and the corresponding one of Titus's clothes. The number and thickness of the successive layers and the nature of the adhesive and pigments could be ascertained. The pigments in the sample were identified by microchemical analysis. In addition to other basic methods, the electronic microprobe made an invaluable contribution to the identification of the elements which were present (ill. 77).

Microscopic study of the sample usually establishes the respective dimensions of the various layers of which the painting is composed; first the layer known as the ground or priming, which may or may not be covered with another layer of colour, then the substance of the picture, composed of one or more layers of colour sometimes coated with varnish or retouched. Stratified samples of the painting can furnish information on the technique, and about the artist's personality, since they show the rhythm of the brushwork and the master touch of the painter (ills. 78, 79).

A new way of using microsamples will now be described.

Staining thin sections

The adhesives of the painting can be identified *in situ* by means of staining. A fragment of the picture is embedded in plastic and sections 40–50 microns thick are cut with a microtome – up to ten horizontal sections from a sample 1 mm long. When a section is microscopically examined by transmitted light, varnishes and layers of purely organic materials such as madder can be identified.

Proteins are identified by means of specific stains. The most widely used are Fuchsin S and Amide Black (ill. 79).

In identifying fatty acids, the use of lipochrome

76 and 77
A microsample taken from the left shoulder of the subject is seen, when studied, to be made up of eight painted layers, four of which belong to the underlying composition, the other four to the portrait of the young man. Within each layer, each individual element has been identified using an electron microscope.

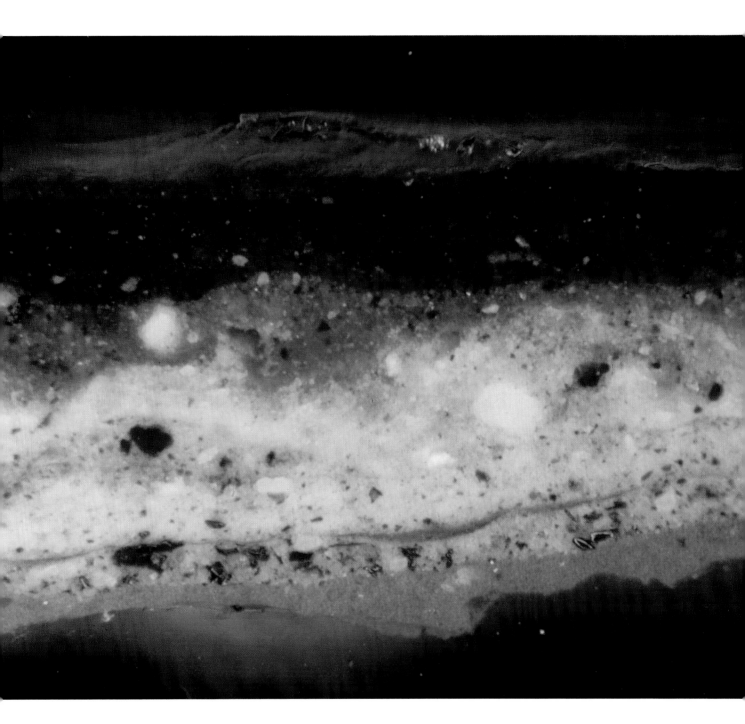

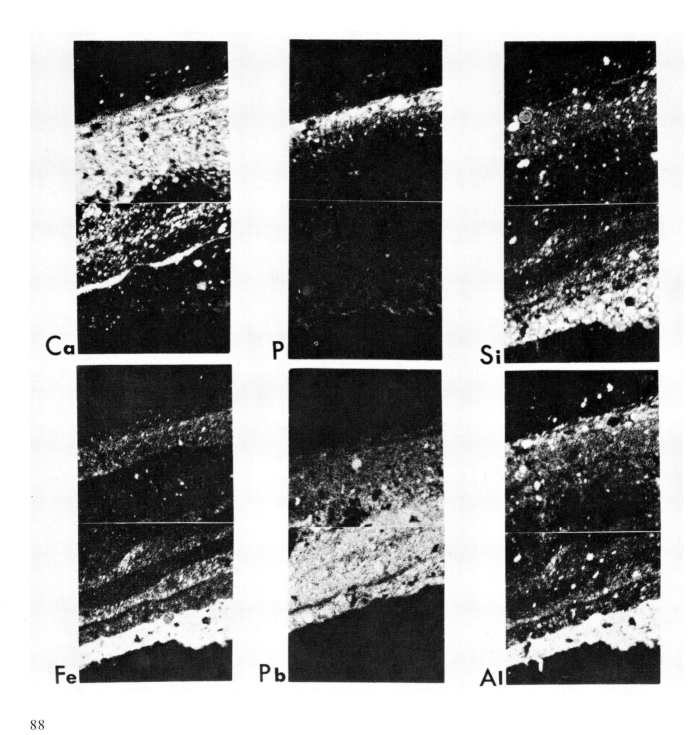

reagents such as Sudan Black must be abandoned because it is preferable to identify them by the shiny brown look of the section when it has been dried and warmed in gradual stages on a hot table.

Starches and dextrins are the only polysaccharides that can be easily identified by their reaction to iodine.

If both proteins and fatty acids are present in one paint layer, it can be assumed that this is either a natural compound like egg yolk or an artificial compound like oil and gum, or egg and oil.

This process has the double advantage of using a very small sample and rapidly locating binding agents in different layers of paint.

A number of tests aimed at increasing the range of this process are currently being researched. Objectives still to be attained are:

– distinguishing between various kinds of protein

– identifying greasy substances such as oils, fats and phospholipids

– identifying various plant juices such as garlic, onion and leek

– identifying mineral ions and, finally, obtaining specific identifications by using fluorescent antibodies whenever possible.

The study of adhesives, colours and varnishes needs all the resources of microchemistry and physics, and this will be dealt with in the section on advanced techniques, but the identification of the wood or fabric of the support can be a valuable source of

78
Microscope used for studying sections including minute samples of paint.

important information to the art historian or restorer.

Wood can usually be identified by microscopic examination, which can determine the nature of the wood, while dendrochronology can establish its age.

Textile fibres

Most paintings have a fabric support which can be linen, silk (though rarely except in the Far East), cotton or hemp. It sometimes happens that a painting on a wood panel has a piece of fabric embedded in the ground. It is useful to be able to identify these fibres when restoration is being carried out.

When a sample is taken from a painting it is seldom more than a few millimetres long, and must be studied by microscopic examination.

The commonest natural fibres are of animal (silk and wool) or vegetable (cotton, linen, hemp and jute) origin. Before the sample is mounted on a slide the fibres must be carefully separated and cleaned of the gum impregnating them; they must then be observed microscopically by transmitted light. Linen, hemp, jute and notably cotton will look coloured. A view down the length of the fibre usually makes it possible to identify cotton, wool and silk or fibres of the linen, hemp or jute type. Only a transverse section will distinguish between linen, hemp and jute.

Identification of fibres is comparatively simple since all their characteristics are described in specialist publications. The reaction to twisting and the strength of the threads can only be determined by experts in the laboratory. It is possible or even advisable to turn to the experts when embarking on the general study or restoration of a painting.

Scientific methods of analysis are all becoming increasingly complicated and accurate. It is important to be able to select the appropriate means of resolving a technological problem and arriving at a diagnosis. However, a masterpiece must not be made the subject of an experiment. It is sometimes necessary to resort to destructive processes, but this can only be justified when it is unavoidable for the preservation of the painting. Science must be the servant of the work of art – not the reverse.

79
Photomicrograph (80× magnification) of a section on which a fuchsin test has been carried out to show the proteins (gelatin paste) contained in the gesso formed by several strata and the sizing under the painted layer.

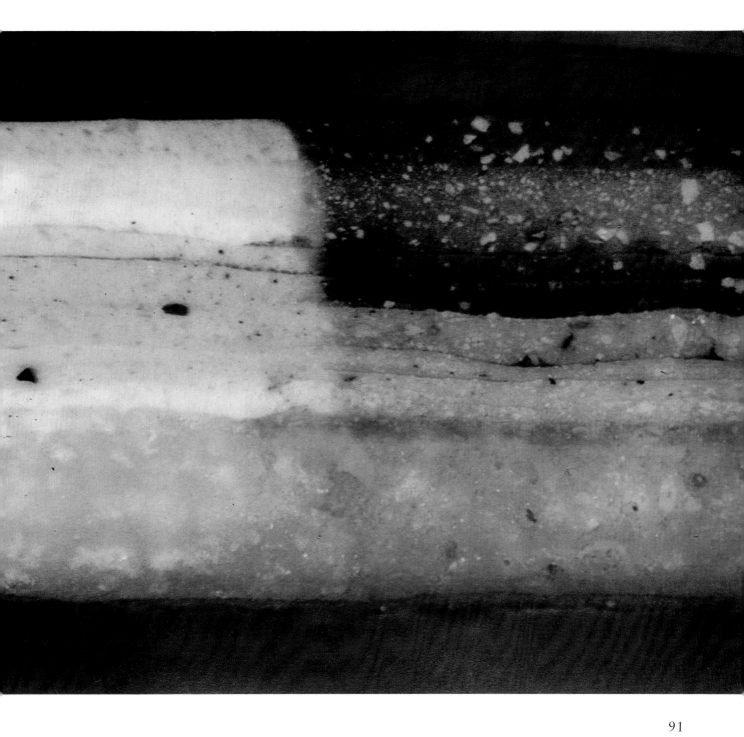

ADVANCED TECHNIQUES

As well as the methods of analysis we have just considered, which are easy to use, requiring as they do modest resources and uncomplicated equipment; there are also more complex methods involving heavy equipment. So one must look to institutes for scientific research, universities and specialist laboratories for researchers who will use these techniques and interpret the documentary evidence in the form of spectrum diagrams or analyses that the historian or art collector can integrate into their own research.

though, physical methods provide more accurate and more rapid results using smaller samples. Hence the prime interest in such methods.

The methods currently used for analysing elemental composition by physical means are as follows:
– spectrometry of emissions in the ultra-violet band
– spectrometry of X-fluorescence
– Castaing's microprobe
– neutron activation
– atomic absorption
– mass spectrometry

1 Pigment analysis

Up to now it has been chemical methods which have provided the analyses enabling us to determine the majority or minority elements in painting materials, as well as trace or ultra-trace elements. Nowadays,

Spectrometry of emission in the ultra-violet band

This technique enables us to obtain an emission spectrum of which the area most widely used is situated in the ultra-violet region between 200 nm and 400 nm.

The sample to be analysed is excited by an arc or spark discharge. Newly-discovered methods of flame excitation allow us to make sensitive, accurate and rapid measures with tiny quantities of sample material.

The constituent elements of a material – from major to trace elements – can be quickly and accurately determined. For this reason spectrometry of emission in the ultra-violet band is a favoured technique for analysing pigments whose composition may be very varied.

Spectrometry of X-ray fluorescence

X-ray fluorescence is a physical technique based on studying the emission spectrum in the X-ray field. The sources of excitation used are either electron flux or a radio-active source or an X-ray tube.

Spectrometry of X-rays is an observational technique which has been used for a long time, as much in physics as in chemistry. However, the apparatus currently in use was originally just not designed to analyse directly either bulky or very small objects. Furthermore, most of it is very insensitive to elements such as copper, zinc, nickel and iron because of the 'background noise' that the equipment itself makes.

X-ray microfluorescence

Equipment has been developed at the Research Laboratory of the *Musées de France* which is ex-pressly designed for museological research. It falls somewhere between the electronic microprobe and the conventional X-ray spectrometer (ill. 80).

X-ray microfluorescence is interesting because it does in fact enable the researcher to work directly on a painting. On the other hand – and this is essential – it does absolutely no damage to the picture. The sample can be recovered after analysis and studied by other methods. Lastly, X-ray microfluorescence does not require any preparation of the sample; it is highly reliable, sensitive and relatively easy to operate.

Castaing's electronic microprobe

For prompt element analysis of painting materials, that confirms chemical analysis and indeed replaces it on occasions, the electronic microprobe – based as it is on the principles and techniques of X-ray emission spectrography – provides a valuable method of approach.

The microprobe is used to solve numerous analytical problems that must be studied at micron level. It enables rapid analysis by scanning, a method which is particularly suitable for studying sections of paint, polished surfaces and thin slivers where the electronic beam can, without damaging the material in any way, probe layers some twenty or thirty microns thick, of different compositions and whose constituent elements are practically inseparable by mechanical means. Within each layer the microprobe thus enables us to identify the elements making up each microcube of material, and it possesses an inherent facility for separating elements

that is vastly superior to that of the finest optical instruments.

Neutron activation

This highly sensitive method, which yields accurate results, is difficult to use because it requires an atomic reactor.

After irradiation in a neutron pile, the sample, now radioactive, emits gamma rays. By studying the nature of these emissions and measuring their intensity, one can work out the chemical composition of the sample. With paintings one is obliged to use samples, and elemental analysis enables the worker to determine major, minor and trace elements.

Recently experiments on a few paintings have been carried out in the USA in order to try to derive an overall element analysis of their surface using a portable neutron source.

The application of these so-called atomic absorption methods, as well as mass spectrometry, is still very much at the experimental stage.

X-ray diffraction

Analysis of crystalline structure is carried out using X-ray diffraction. This technique enables us to analyse pigments based on their three-dimensional atomic structure. Only crystallized pigments can be identified thus, be they organic or inorganic. Very small samples, measured in milligrammes, are needed for analysis in the Debye-Scherrer chamber.

2 Analysis of binding materials

Infra-red absorption spectrography

The absorption spectra obtained by infra-red light emitted by a source across the material to be analysed (be this the painting medium or the varnish) are band or line spectra that are of molecular origin. Infra-red analysis has its most direct application in organic chemistry; where it is used to identify, through the spectra obtained, the various reactions of the carbon atoms of the organic molecule as well as the different functions – alcohol, ketone and peroxide of the hydrocarbon derivatives.

The spectrograms which are obtained in this way show the composition of organic substances and enable us to identify the oils, lacquers, varnishes, waxes, resins and bitumens that go to make them up.

Gas phase chromatography

Chromatography in a gas phase is a technique for analysing in both qualitative and quantitative terms the constituents of a mixture (binding material and

80
X-ray micrography equipment for qualitative and quantitative analysis directly from a picture, for use on surfaces varying from 0.01 mm^2 to 1.00 mm^2, with a degree of sensitivity that can show up concentrations as small as 0.01%.

mm/

pigment) in so far as these can easily be volatilized. It has the advantage of being usable even when one only has access to a very small sample of material. In easel-painted pictures the most commonly used binding materials usually contain greasy substances; quick drying vegetable oils like linseed, nut, marigold, and egg yolk used in tempera techniques. These products of natural origin are complex mixtures of diverse molecules which for the most part are built up from a small number of simpler molecules, the fatty acids. The amounts of each of these fatty acids in the sample under analysis vary according to the nature of the binding substance. Chromatography enables us to separate the various fatty acids in the sample, to identify each of them, compute their relative quantities and thereby arrive at a way of identifying the oily binding material (ill. 81). This technique can be equally useful for determining the nature of other kinds of binding materials such as proteins, gums, etc.

3 Methods of dating

Dating the constituent elements of painted material is being studied in several laboratories in the USA, France and Germany. Mention should be made of four methods which are still at the experimental stage:

81
Chromatogram for identifying binding substances.

Carbon 14 dating

Recent work at the Mellon Institute, USA, has enabled researchers to apply this method to identifying recent (that is less than 100 year old) forgeries. In fact since the beginning of the twentieth century the amount of carbon 14 in the biosphere has changed, through industrial and nuclear activity, and the concentration of C 14 has doubled since 1900.

The difference between a modern and an old oil can therefore be established from relatively small samples (30 milligrammes) using miniature computers.

Measuring isotope proportions in lead

One of the most commonly used pigments in the history of art is white lead. Isotopic investigations of pigments containing lead can therefore be extremely useful in discovering where or when a picture was painted.

In fact the isotopic properties of white lead are characteristic of the ore from which the metal is derived. Research being carried out, in particular, in America at the Mellon Institute, Pittsburgh, is aimed at discovering the origins of the lead ore used for the white-lead pigment in paintings from different periods. The results obtained from this work should enable the researchers to regroup the paintings by school, by artist and so on, and consequently lead to dating the pictures by comparative means.

Neutron activation to measure impurities contained in white lead

One compares the levels of impurities that have been discovered (the proportions of tin, zinc, and copper, for example) with samples from different periods taken from paintings of known dates. As manufacturing techniques have varied over time, it should be possible to establish reproducible graphs of impurity proportions as a function of the age of the painting.

Natural radio-activity of lead

Another method developed at the Mellon Institute is based on the fact that a sample of modern white lead (that is, less than 100 years old) has different radio-active concentrations of lead 210 and radium 226, both produced through decay of uranium 238 which is in an impure state in lead ore. In a sample of old white lead, on the other hand, there is practically no difference in these two concentrations.

ENVIRONMENT AND CONSERVATION

In the preceeding section we have concentrated on analysing the painted picture at both surface level and in-depth, globally and locally. The knowledge gleaned from such analyses should enable us at least to keep in check the ravages of time. But it is also vital to control the damage wrought by the environment. Ambient climate as well as lighting of pictures should, if they are to be beneficial, be carefully controlled. This section is concerned with detailing the correct conditions because these are fundamental to conserving pictures, both in original or restored form.

1 Climate

One essential condition for the survival of painted works of art is climatic stability in the place where they are to be conserved. Whether a painting be on wood, paper or canvas, it is sensitive to temperature and humidity variations. A work of art is a complex organization of different materials, each of which reacts according to its natural properties. Wooden panels, on which many very old pictures are painted, have different expansion coefficients according to whether they are made of oak or soft wood. As the painted layer reacts to humidity less quickly than the support, many panels expand, crack, and warp around the prepared and painted side, with the back of the picture continuing either to expand or contract.

Our predecessors did not fail to notice such changes which is why, before the sixteenth century, many pictures were painted on both sides so that the wood support would be spared the strains that could damage the picture.

We see this with Van Eyck's *Virgin of Autun*. The main side has the admirably composed picture of Nicholas Rolin at prayer before the Virgin, while the back is coated with a thick preparation covered by a mottled painting that was done to balance the

stresses, to stabilize and protect the oak panel. In the Middle Ages certain panels had more elaborate compositions on the back, such as first sketches or coats of arms, which were designed to decorate the reverse as well as to keep both sides in balance. The back could also, more simply, be covered with gummed films or cross pieces, of varying kinds. These pictures are usually well preserved for the reasons mentioned above.

During the Renaissance, paintings in Europe were no longer exclusively destined to be housed in religious establishments but figured in the surroundings of private life. They were conserved in castles and mansions, places that were well protected from sudden changes in outside temperature by thick walls, tapestries and wall hangings which tend to balance and suppress acute temperature and climatic variations.

The same was true in the seventeenth and eighteenth centuries. Paintings were then done on canvas, a more supple support which adapts more readily to climatic variation. It was in the nineteenth and particularly the twentieth century that the problem of conserving paintings assumed an alarming aspect. Central heating accounts for more damage to pictures than wartime! By drastically changing, within a matter of hours, the climate of a room, central heating gives rise, in paintings on wood or canvas, to stresses that cause splitting, peeling or blistering. If the gallery curator or collector does not remedy matters, it soon becomes impossible to move the picture or even to restore it. Damage like this, however, can be avoided, provided the importance of climate is recognized and two aspects controlled. Temperature and humidity must both be kept at constant normative levels. A desirable temperature is around 20° Centigrade and the relative humidity, i.e. the relative level of humidity in the air recommended by international bodies, should be between 50% and 60%. A lower or higher temperature than 20° Centigrade is not incompatible with effective conservation, provided that it is constant and that, if it is changed to make the surroundings comfortable for people, this is done gradually. These norms apply to temperate climates. In continental or tropical conditions the conservation climate must be stabilized according to the norms prevailing in the areas of origin of the work in question. Thus Western works of art conserved in Japan for example are displayed under conditions similar to those needed in Europe. A case in point is the famous *Mona Lisa* of Leonardo da Vinci which is kept in the Louvre at a temperature of 18−20 °C, with a constant relative humidity level of 55%, with tolerances of plus or minus 5% being allowable. When this most famous picture in the world left France, an air-conditioned display case was built in Tokyo which would enable the National Museum of Japan to maintain constant climatic conditions analogous to those under which the painting was kept in the Louvre in Paris. What is more, the picture was transported in an isothermic container designed to maintain the required climatic norms throughout the journey. The exceptional trouble taken over the *Mona Lisa* was particularly justified as the picture is painted on a softwood panel of Italian poplar which is highly sensitive to hygrometric variations.

Heating in private houses is often excessive. It is not unusual to find, especially in the USA, domestic temperatures around 25° Centigrade and relative

humidity as low as 30–35%. Extreme dryness like this desiccates materials, especially paper and wood; fibres shrink, split and crack. That is why there is nothing worse than hanging a picture near a radiator or, even more so, directly above one. This will undoubtedly ruin it.

Extreme humidity is hardly less damaging. If the hygrometric level of the atmosphere reaches 80–95%, it is obvious that wood will swell, canvas will go musty, and probably the surface preparation between the support and the painted layer will tend to become powdery and come away from the support.

The modern collector must carefully regulate the climate surrounding the works being conserved and, to this end, can use certain measuring instruments. First of all there is the thermometer for measuring ambient and local heat in order to stabilize temperature, and to choose the most favourable spot for hanging fragile pictures, especially those painted on wood. Then there are recording hygrometers (ills. 82, 83) which should be used as often as the thermometer for measuring humidity levels and controlling the degree of water vapour of the ambient air. (These instruments are sensitive and easily liable to get out of working order. They should be adjusted using a psychrometer.) If the atmosphere is too humid it is possible to remedy the situation by using a dehumidifier or by gently raising the temperature by stages until the atmosphere is kept at the required humidity level. If the atmosphere is too dry (RH should never drop below 40%) it is possible to humidify it using containers of water, window-boxes or humidifiers which give off water vapour into the atmosphere.

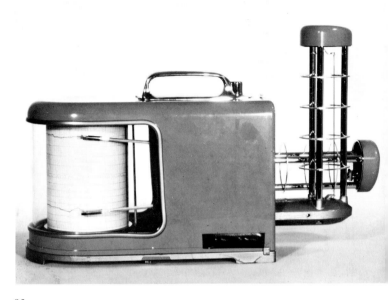

82
Thermohygrometer equipment for recording temperature and relative humidity.

Industrial air conditioning installed for human comfort in those countries where the climate varies enormously should not only be regulated to provide the most favourable conditions for a work of art; it is also vital to incorporate measuring equipment independent of the main installation to offset the effects of sudden stoppages of the air conditioning systems through breakdowns, strikes, etc. which would be particularly harmful to pictures. Also, during very cold spells when the air is very dry, care should be taken not to turn on or intensify the heating system and thereby dry out the ambient atmosphere even more. An awareness of the many-sided nature of conservation problems is vital to solving them. It is horrifying to think that a collector might allow a coveted and valuable picture to be

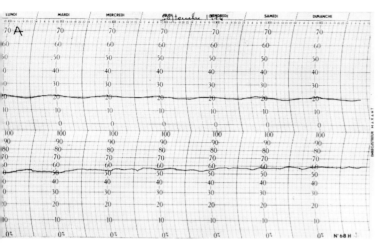

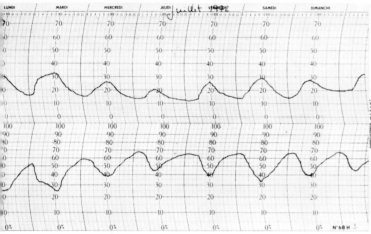

83
Above: Temperature and hygrometric readings showing stable climate. Below: Temperature and hygrometric readings showing very wide variations and bad climate.

ruined through sheer negligence or ignorance. And, lastly, it should be remembered that these measures to preserve paintings should be employed as much when storing them as when exhibiting them.

2 Pollution

We live in an age that is aware of the dangers created by pollution in society. This pollution is becoming more widespread and threatening human survival and the continued existence of works of art. Monuments break up, statues and cathedrals are subjected to forces that damage and displace stonework, and it is clear that small sculptures and paintings are not exempt from the ravages of the surroundings.

We know that air is a mixture of one part oxygen, four parts nitrogen and small quantities of carbonic and rare gases. So far as the collector or curator is concerned, the important constituents in the atmosphere are oxygen, water vapour, sulphur dioxide, nitrogen, and carbonic gas. The rare gases which are practically inert, hydrogen disulphide and ozone rarely damage *objets d'art*.

The oxygen in the air plays a major part in the process of chemical change in works of art. It causes among other things, yellowing of varnishes, weakening of fabrics and discolouration of numerous pigments. These reactions are encouraged by light (photo-oxidation).

Sulphur dioxide brings about substantial damage because it changes into sulphuric acid and attacks paper, cotton canvases, linen, frescoes, limestone and obviously paintings.

As well as these depressing effects, we should also bear in mind urban impurities which are usually of a tarry nature. They cling strongly and can sometimes stain. However skilfully pictures are cleaned there are risks involved, and it is always preferable to avoid or defer cleaning. Of course this is not

exactly a modern phenomenon. At the end of the seventeenth century a writer described "the destruction wrought by dirt carried on the breeze, especially that which pervades large towns like Paris, a dirt which penetrates the finest varnishes."

So when an art collection is housed in a town or an industrial region, provision must be made for filtering the surrounding atmosphere. Likewise for collections located in arid regions, where dust and sand are carried on the wind. Mention may be made of two ways of eliminating particles suspended in the air; cloth or plastic foam filtering and electrostatic precipitation. Electrostatic vacuum cleaners are effective but not always to be recommended as they produce small amounts of ozone and nitrous oxide. There are textile filters that will eliminate more than 99% of dust suspended in the air. It may sometimes be necessary to keep paintings under glass, provided there is a sufficient gap between the surface of the painting and the protective glass to permit the circulation of air.

3 Vibration

Another product of modern life is vibration, a danger to paintings that needs to be kept in check if the sometimes delicate combinations of materials are to be protected. There are two kinds of vibrations:

- Aerial vibrations – noise – characterised by amplitude and frequency (measured in db units)

- Solid vibrations transmitted through buildings and floors. Their effects on human beings are less understood than they are on works of art.

There are a number of sources of vibration:

- Individual vehicle or general transport vibration in the immediate vicinity of the museum or gallery (noise plus solid vibrations)
- Technical equipment in buildings such as elevators, hoists, escalators, ventilation machinery, cleaning equipment and so on (noise plus solid vibrations)
- Cleaning or moving pictures (solid vibrations)
- Various other sources such as music (aerial noise).

Vibrations can be measured using seismographs. Protection from aerial vibration can be instituted at several levels:

- At the source, by reducing the emitted noise level, which implies a conscious awareness on a national and international scale
- By partitioning using cushioned flooring, elastically-mounted or suspended baffle boards, false ceilings and special treatment of all openings like doors, windows, air vents and so on
- By fittings, using absorbent materials (thick pile carpets, acoustic ceiling tiles).

Protection from solid vibrations can also be instituted at several levels, depending on the source of the trouble. A combination of the following methods may be used:

- Structural modification of buildings whereby certain structural components are made less rigid (for example using chloroprene rubber joints under supporting beams)
- Improving flooring by light or heavy-duty cushioning on fibre glass or by laying soft pile carpeting

- Modifying the walls and partitioning using elastically-fixed baffling
- Fixing movable equipment such as display cases or portable hanging rails on anti-vibration bases or buffers
- Making sure that the works of art themselves have been fitted with specially-adapted hanging or display devices.

Awareness of the problems of vibration should lead to adequate protection against it.

4 Lighting

Lighting for paintings and the harm it can do are facts of modern living. In former times our ancestors, having seen the damage wrought by sunlight (pigment discolouration, material changes, etc.) kept what pictures they had away from direct exposure to sunshine. They hung heavy curtains at their windows and, what is more, the glass used in those times filtered harmful radiations. From dusk onwards, the gentle light of candles or oil lamps could not harm paintings unless a candle was placed too near a picture and damaged the varnish or painted layer. But this was due to excessive heat not light.

However, since the advent of electricity, lighting levels have been relentlessly increased – to the extent that we live in an age where light is in superabundance.

The rise in the general level of illumination has had harmful effects on picture conservation. Since it is the picture itself that needs to be emphasized, often too much light is directed on it.

Before looking at the twofold problem of picture lighting – the technical and the aesthetic – we should bear in mind that the term "light" refers to the electromagnetic radiations to which our eyes are sensitive. These are between 800 and 400 nm. Whatever the light source, be it natural (sun, sky) or artificial (incandescent lamp, fluorescent tube, etc.) it emits, as well as visible light, dangerous radiations, which are imperceptible to the eye and thus do not increase the degree of illumination.

These radiations consist of ultra-violet and infra-red rays.

Ultra-violet radiations have dangerous photochemical properties. Those with wavelengths of less than 360 nm are roughly one hundred times more harmful than those with wavelengths between 360 nm and 1000 nm.

These photochemical properties are also shared, though to a lesser extent, by visible radiation, the wavelength of which is close to that of ultra-violet rays. The latter make no contribution towards enhancing the look of works of art so there is some point in eliminating them as much as possible. But it would also be desirable to reduce those visible radiations with wavelengths between 400 nm and 500 nm, provided that in so doing aesthetic requirements are not overlooked.

Infra-red rays with wavelengths over 760 nm are equally invisible but they do produce thermal effects which can bring about chemical reactions that are serious for paintings.

However, it must be pointed out that not all objects are equally sensitive to these radiations. The most vulnerable ones are those containing organic matter

such as pigment and colouring materials, fabrics, and inks which are particularly easily harmed. So paintings (especially watercolours), manuscripts or printed books, tapestries and textiles and so on are all at risk. Furthermore, not only do pigments and lacquers discolour, but exposure to light can make oils go yellow and fade varnishes, while paste or casein binding materials become brittle and shrink. Painting supports are equally susceptible to infra-red radiations which raise the temperature and thus dry out the material. Wooden panels get distorted in this way. Certain kinds of untreated timber tend to darken under light while painted wood discolours. Canvas and fabric backings also suffer from these radiations:

– cellulose along with other organic substances oxidizes and, as a result of both light and humidity, they decompose through hydrolysis or depolymerization.

Damage caused to works of art through light is generally more serious:

– the longer the exposure time
– the greater the intensity of rays in the overall direction of the object
– the higher the proportion of blue, violet and ultra-violet radiations in the rays
– the shorter the wavelength of the ultra-violet rays
– the stronger the infra-red radiation
– the higher the ambient temperature and humidity.

Paintings and other objects must be illuminated but in a controlled, measured way. Light sources can be natural, artificial or mixed.

Natural lighting

Natural lighting, coming from direct sunlight, is to be avoided. We know that protracted exposure to sunlight has thermal and photochemical effects that are as dangerous for humans as for paintings. Diffused light, even from the north, must be carefully measured because it changes and shifts constantly while artificial light, whether incandescent or fluorescent, is inert, unvarying and easy to regulate. Natural light varies considerably according to whether the sky is bright or overcast. So objects that are sensitive to light should be kept in the shade, away from both direct sunlight or from the light of a cloudy sky. Natural light coming through windows or glass partitions should therefore be filtered and regulated just like artificial light. One should also bear in mind the direction from which the light is coming. It can be lateral (via windows) which is the most conventional method, overhead (which illuminates the greatest surface area) and even diagonal.

Artificial lighting

The properties of rays emitted by artificial light sources vary according to the type of source. There are two main types:
– incandescent lamps
– discharge lamps or fluorescent tubes.
Incandescent lamps give off rays spread over different wavelengths in the visible spectrum and have significant *thermal* qualities as they emit strong infra-red rays.

There are many types of fluorescent tubes, varying in the intensity of colour and the temperature of the light they emit, but they all generate strong ultra-violet radiation. Only tubes with double filtering shades are almost totally harmless.

There is no natural or artificial light source whose rays are altogether harmless, but that is no reason to keep works of art, that are made to be seen, in complete darkness.

Yet conserving such works demands constant vigilance to see that lighting never goes above certain danger levels: 50 to 300 lux are the amounts suggested by international recommendation, but the figure of 180 lux should be regarded as an acceptable average. In addition one should not forget that *harmful effects are cumulative and therefore in proportion to exposure time.* Thus 1000 lux illumination for one hour is as damaging as 100 lux for ten hours.

Photochemical and thermal reactions are lessened proportionately with any reduction in lighting level and exposure time.

MEASURING EQUIPMENT

For measuring light rays falling on a work of art, the *luxmeter* is a vital piece of equipment for amateur and professional alike. It gives a direct reading of the amount of illuminance, measured in lux, received by the object in question (ill. 84) and thereby enables one to know the strength of the lighting sources, to change their position, or to filter them — in short to control both lighting sources and their attendant dangers.

The *thermometer* enables one to measure the thermic effects of infra-red rays emitted by sunlight or incandescent light. As fluorescent light emits little

infra-red radiation, its thermal effect is slight, but light sources of this type do emit ultra-violet rays which are less easily measured because the so-called *ultra-viometer* is not always sensitive to low wavelength ultra-violet rays. This is why it is easier and safer in all cases to interpose between the light source and the object to be illuminated a filter to screen off near ultra-violet rays.

FILTERS

One can drastically reduce the amount of radiation falling on a work of art lit by natural light by using, as necessary, canvas or venetian blinds, or better still by replacing window panes with inactinic glass or diffusing glass of the thermolux or triplex variety. There is also a less complicated solution, using anti-ultra-violet varnishes, though their effective-

84
Luxmeter. An instrument for measuring illuminance of a given surface.

ness decreases with time. Filters or plastic shades can be used over fluorescent lamps or one can even use sleeves surrounding the whole tube.

At all events it is desirable to separate the lighting sources as far as possible from the object to be lit so that the danger of heating is correspondingly reduced. That is why footlighting or strip lighting perched on the end of an arm just a few inches from pictures should never be contemplated.

Nowadays the multiplicity of light sources available goes hand in hand with the many ways of protecting pictures. So it is vital to be aware of the dangers inherent in any given source. If a few precautions are taken at the outset, whenever a fragile picture is hung, damage can be kept down while still showing off a painting clearly, though under a reduced intensity of illumination. One should also reckon with another important factor, namely the colour temperature of the lighting employed. Intensity and colour of artificial light can be regulated – a fact of some aesthetic importance. Fluorescent light has the cold, blue quality of northern light and suits paintings done in north-lit studios like those of Ingres and Van Eyck.

Incandescent yellow-red light recalls the light of the midday sun and so is better suited to illuminating Impressionist paintings. Remember too that all light, whatever its source, has a colour temperature that is measurable (in degrees Kelvin) and that the choice of colour temperature should give the picture a luminous quality that has colour properties close to those with which the painter conceived and executed his work. It is gratifying that nowadays we can use technical advances to improve the aesthetic conditions under which we present and light paintings. Yet the central preoccupation should be to conserve works of art, and it behoves us to ensure that natural lighting be mastered just as much as artificial light and that the recommended levels be adhered to.

CONCLUSION

Given that scientific techniques for analysing works of art add a new dimension to our understanding of both their historical evolution and the creative genius behind them, it is essential that we approach these exploratory techniques with a more rigorous methodology than has hitherto been employed. Research in these fields continues to be sporadic and localized. Firstly there must be standardization in working methods and in recording evidence, so that like is compared only with like. Furthermore, the standard procedures that the technician follows in obtaining his evidence should not be overlooked by the person using his findings when he comes to evaluate that evidence. So an X-ray film of an unknown painting by Leonardo da Vinci should be taken under conditions comparable to those in which radiography of the *Mona Lisa* has been done. Only then can comparison be scientifically valid.

The rules laid down by Fontenelle at the beginning of the eighteenth century as the basis of research are still to be recommended for studying paintings by scientific means. Firstly "explain the unknown through what *is* known" without falling back on subjective notions; do not assume the right to deny the value or interest of evidence or a particular method under the pretext that they seem hermetic, however natural it may be to call a thing false if it is deceptive or surprising; never forget that the evidence we judge in this way is most often that which is most difficult to prove. Analyses should be an integral part of research. Pictorial evidence must from the outset be interpreted from the technical, historical and aesthetic points of view, which is where experience and sensitivity come in. This new approach leads to a far deeper understanding of materials and techniques and in turn, better conservation of

objects. It does, in addition, put the material aspect of a work into its true perspective in the creative achievement.

It does not take long to learn how to interpret photographic and radiographic evidence, and any interpretation or practical application should be approached in two ways – vertically and horizontally.

The *vertical* study consists of a comparative examination of the look of a work of art and the documentary evidence drawn from it, using all the different kinds of radiations available in order to spot differences or similarities of a technical or aesthetic nature. These might be changes in the composition, the style or intention of the artist, repainting, damage and so on. In other words, an in-depth study.

Each piece of documentary evidence should then be worked on *horizontally*. Here one does a comparative study of evidence of the same type derived from different works of art. One studies photomacrographs or X-ray pictures of the works of one artist or one school of painting. In order to trace the evolution of a particular style or technique, with similarities or differences being highly instructive for the researcher. Alongside this kind of scrutiny which is based on a comparative methodology, documentary evidence may be studied according to scientific criteria quite independently of conservationist or historical considerations. For example infra-red photography can enable the researcher to identify certain pigments, or X-ray photographs can provide information on the atomic weight of materials.

As well as the evidence derived from global analytical methods, there is that which comes from localized study of a given point on a picture's surface. Microsampling of some twenty or thirty square microns enables one to obtain from a given spot a stratigraphic analysis that will confirm observations made using global methods and will also provide information on the artist's craftsmanship and temperament. The applied use of microsamples is possible through chemical methods of element analysis which require the participation of a specialist, either a physicist or chemist. Thus the study and conservation of paintings which hitherto has been something of a "closed-shop" is now becoming a subject for interdisciplinary research.

The pictorial evidence obtained by the methods we have just described in the first part of this book can, after a brief initiation period, be used and interpreted by art-lover, restorer and historian alike, while the analyses and graphs obtained by physico-chemical methods require the efforts of physicists or chemists. The outcome of these investigations and the results of the analyses are highly informative both for the study of the evolution of technique and for the light thrown upon the craft and behaviour of the artist. So it is that Rembrandt's irrepressible and technically perfect skill as a craftsman comes across to us not only through X-ray pictures but equally so through photomicrographs taken from sections of his painted matter.

Forgotten images and changes of heart on the part of the artist are seen again along with the very rhythm of his brush. Both provide us with insights into the painter's craftsmanship and his psychology as well as the state of his picture, because the quality of any work is surely reflected in its structure.

Throughout this book we have tried to enumerate the various methods and techniques of examination and analysis, to show how they may be applied and to point out their limitations as well as their merits. While this book contains detailed information on how documentary evidence on the state of pictures may be obtained, the use and interpretation of such evidence is very much a matter of personal experience and sensitivity, as each work of art has its own individual quality. Only close collaboration between historians or art collectors and restorers and scientists will push forward this research which, by enabling us to increase our knowledge of painted masterpieces, will lead us to conserve, protect and treat them more effectively.

It is to be hoped that this book will stimulate awareness of the importance of the material aspect of paintings in their conservation and in our perception of the painter's message, as well as an awareness of the importance of the environment in preserving pictures.

TECHNICAL NOTES

These notes are aimed to provide supplementary information for the reader. They are the results of practical experience: they are not meant to replace the theoretical knowledge which is to be found in the publications mentioned in the bibliography. They are the results of joint experience from the *Laboratoire de Recherche des Musées de France.* I wish to express my gratitude to all the members of the Laboratory, particularly those who helped in the preparation of these notes:

Mrs. S. Delbourgo
Mrs. F. Drilhon
Mrs. S. Efeyan
Mrs. L. Faillant

Mr. C. Lahanier
Mr. J. P. Rioux
Mr. M. Solier
Mr. A. Tournois

1 Photography using raking or tangential light

The technical problem to be solved is that of determining the exposure time as a function of the colours of the picture, and of the distance between the light source and the subject. The sensitivity of most photoelectric light meters is insufficient for very low levels of lighting. Light meters give useful information about compositions where the amount of reflected light is ample enough to give accurate exposure times. When conditions are unsuitable for light metering, one must compensate for the deficiency of indirect lighting by increasing the length of exposure. It is necessary to multiply the exposure time by 15–30 times bearing in mind of course, the distance separating the light source and the subject; and the lighting angle. (It is recommended that panchromatic film be used in view of the varied colours and tones of most pictures.)

2 Infra-red photography using monochromatic sodium light

This source of light unites radiations within both the sodium emission spectrum and the infra-red region (818 to 819 nm). Infra-red photographs can be taken by filtering out the visible yellow light, thus

allowing only infra-red rays to pass through. The infra-red rays transmitted by the filter give sharper definition to documents as long as fresh emulsions are used which are sensitive to infra-red. The quality of images obtained by this technique of infra-red photography seems better than that of photography using infra-red from incandescent lamps.

The spectrum is practically monochromatic and this gives better definition. In practice, one focuses using a pair of visible yellow rays, and then one increases the distance between the lens and the object by $200 \times$ the focal length to get infra-red focusing. The exposure time must be found in advance by trial and error. Theoretically exposure times are 3 to 6 times longer than for exposure using incandescent light; however, this depends on the subject.

3 Photomacrographs

The degree of enlargement of photomacrographs and photomicrographs in this publication is indicated as a linear multiple:

Example: photomacrograph ($\times 4$), page 35.

To obtain the area of enlargement, one merely squares the given multiple, e.g. $\times 4$ linear $= 16$ (area).

4 Plastic image

The procedure called "plastic image of the surface" was perfected at the Scientific Research Laboratory of the National Museum of Warsaw. Some good examples of this are reproduced in the study by Kasmierz Kwiatkowski, *Sur la Dame à L'Hermine*, published by Editions Ossolineum, Warsaw, 1955.

5 Photographing fluorescence under ultra-violet light

For colour photography under ultra-violet fluorescence daylight colour reversal film on high speed is especially recommended to reduce exposure time. A slower film is sometimes a better register of each individual fluorescent colour. It is then necessary to place a filter of 420 nm over the lens which stops not only the U-V but also the excess visible blue from the lamp which would otherwise be the dominant reflected colour. In certain instances, in addition to the afore-mentioned filter one must add a colour correcting filter for better colour fidelity. The lens for fluorescent light photography can be of any type since the subject is autoluminous in the visible part of the spectrum, but the ultra-violet light must be filtered out totally.

The U-V filter absorbs ultra-violet radiations which cannot be absorbed by the lens coating, and it transmits only visible radiations. It is important that filters used in ultra-violet light photography do not interfere too much with the fluorescent effect. Ignoring this detail results in an image lacking in contrast. In general exposure times vary according to the speed of the film (orthochromatic or panochromatic), the quantity and quality of U-V lighting (lamps or tubes), the quality of ultra-violet fluorescence emitted by the painting (pigments or varnish), the type of filter used and the aperture.

In most instances, for an aperture of F11, exposure time is between ten minutes and an hour.

6 Ultra-violet photography

Usual sources of ultra-violet rays are fluorescent tubes containing mercury vapour in a partial

vacuum, called "black light" or Wood's lamps, which emit wavelengths between 300 and 400 nm of which the maximum emission energy is between 350 and 365 nm. The camera lens is fitted with a filter allowing only these invisible wavelengths through and absorbing all visible light (for example Kodak Wratten 18 A filter or a Schoot UG 11). As focusing will depend on the wavelength of the light used, it is suggested that focusing be done firstly by trial and error. In practice, a sharp focus is obtained visually, then the necessary compensation is achieved by reducing the aperture to obtain a better depth of field.

7 Infra-red photography

The infra-red spectrum begins at the limit of the visible spectrum and stretches into the region of much greater wavelengths. Only the near infra-red is employed in photography. The sources are the sun and electric arc lamps. Infra-red lamps used for drying are an equally good source, but they are dangerous to painted works because they emit too much heat. The most satisfactory source of infra-red for photography is the electric incandescent lamp. There are many emulsions sensitive to infra-red light backed on to glass or more usually film. We need not review these various emulsions because the technical information is contained on the film packaging. Each type of infra-red film will have its own specific properties of sensitivity and contrast. Sensitivity is usually given in ASA. The exact exposure range is variable, depending on the type of light used and because metering devices are only sensitive to visible radiations. It is best to proceed by trial and error by adjusting the lighting in each case, using the exposure indices marked on the trade description leaflet of the film packet; exposure times can never be more than a guideline for the early trial shots taken by the photographer. The exposure time will depend on the lighting and the absorbing properties of the painting. Infra-red sensitive emulsions are less stable and less durable in storage than ordinary emulsions. Storage in a cool place, or under refrigeration will delay deterioration of these emulsions.

Any good-quality camera should suffice for infra-red photography. Certain precautions need, however, to be taken: camera bellows of yellow leather can allow the passage of infra-red rays through the leather. Preliminary trial of the camera is advisable. The focal distance of a lens varies according to the wavelength of the light. The focal length is slightly larger for infra-red than visible wavelengths when focusing infra-red light. The lens must be moved further from the film plane than if one was in focus with visible light. If one cannot adjust the aperture sufficiently to increase the depth of field, and if the lens does not carry the necessary guide marks, one must decide what corrections are necessary by trial and error. To do this take as the starting point an extension of the focal distance of the lens by about $1/200,000$. In principle this correction ceases to be necessary if the diaphragm aperture is set small, and if one uses an apochromatic lens. Great care is necessary in handling the films or plates during loading or developing. One must avoid touching the surface of infra-red sensitive emulsions to prevent fingerprints appearing. Films must be handled and developed in total darkness and protected from any warm objects which might emit infra-red.

Filters: infra-red photographs cannot be done with-

out a special filter which partially or completely impedes wavelengths other than infra-red. The colour of the filter ranges from dark red to almost black red. The choice of the filter depends on the sensitivity of the emulsion for particular wavelengths. Many firms have manufactured or still manufacture these types of filters, i.e. Agfa, Ilford, Kodak. Let us use the latter brand as an example: The filters manufactured by Kodak are currently called "Wratten filter:" Wratten 89 B from 680 nm; Wratten 88 A from 730 nm; Wratten 87 from 740 nm; Wratten 87 C from 800 nm. Each filter requires an adjustment of the exposure time implied by its co-efficient.

8
See: J.R.J. van Asperen de Boer, "Reflectography of Paintings Using an Infra-red Vidicon Television System," In *Studies in Conservation,* vol. 14, 1969, p. 96.

9 *X-radiography of paintings*
X-ray cameras are of the same type as those used in industrial radiography, but they are different from medical radiography machines. There are two principle types of cameras:
1. The cameras producing soft X-rays between 50 and 90 kV, with a tungsten anticathode tube and an aluminium window with oil coolant. The intensity of rays conveyed can vary between 0 and 6 mA (milliamps).
2. Cameras producing even softer X-rays, between 5 to 50 kV with the tube having a beryllium window and the tungsten anticathode being cooled by water. The intensity of X-rays can vary between 0 and 25 mA.

The first type of camera is in use for radiographs of paintings on canvas. The second for paintings on wood. This is not a rigorous distinction, but allows for an initial choice between cameras to be made. For a particular picture one must choose between one or the other camera for the best results. The distance between the tube and the picture varies from 0.70 metres to 1.50 metres in distance. A longer distance can sometimes be used.

Exposure times vary between twenty and ninety seconds depending on the apparatus and the intensity of the X-rays. With the first camera, exposure time varies between 20 and 90 seconds for a penetration using between 25 and 60 kV and an intensity of 3 to 6 mA.

With the second camera, exposure times vary from 20 seconds to a minute for a picture using penetration of 10 to 40 kV and an intensity of 5 to 15 mA. Fast or semi-fast films of an industrial variety are usually used. These films give contrasting pictures with good definition without the need for excessively long exposure times. The picture should not have too much contrast if one wants to obtain as much detail as possible.

The films are not in cassettes nor in screens but are placed within paper envelopes and are put directly in contact with the painting.

The film is placed on the reverse side of the painting, if it is on canvas, in close contact in order not to get any image from the wooden frame. For paintings on wood one must take into account the thickness of the material. Film is placed on the picture surface to get a sharp image.

Radiographs of large paintings require several films,

these must be carefully overlapped to get coverage of the whole painting. The exposure and developing must be identical for each frame in order to ensure an equal value of contrast throughout the whole.

10 Tomography or stratigraphic radiography

Principle: this method allows the painted surface to be photographed with as little as possible of the support, such as when the picture is painted on parquetry or thick wood.

A special apparatus is required. The painting is placed on a horizontal trestle, whose distance can be varied (90 cm approx.) from the X-ray tube placed beneath.

The radiographic film is placed directly next to the painted surface, the contact being as close as possible.

The X-ray tube is mobile, and moves on a cradle through the arc of a circle of about 750 mm radius. The apparatus is in turn mounted on a structure with four wheels and four jacks, which manually fix the structure in the desired position during photography.

The X-ray tube moves through the arc at a constant speed without prejudicing the uniformity of the radiation of each part of the film's surface. The arc through which the X-ray tube travels is 140 degrees. The axis of the beam is directed to the centre of the arc whilst the beam constantly sweeps over the surface of the film. Points on the picture very close to the film will give a clear X-ray image. Any points on the picture further from the film will give an image depending on the angle of the incident radiation, and this will result in blurred detail which is superimposed on the detail of the parts closer to the film.

Technique of stratigraphy: The first scanning or sweeping action of the X-ray tube is along a vertical plane, the rays being directed upwards. This arc is repeated by rotating the apparatus horizontally in three other vertical planes separated by 45 degrees from each other, in order to eliminate undesirable images (parquetry, second painted surface) from the paint surface being studied.

The time taken to traverse the arc takes 15 seconds making one minute for a total of four manoeuvres. As the exposure time is fixed for one minute, one must adjust the milliamperage and the voltage (kilovoltage) appropriately.

The adherence of the film to the picture surface is much more important in static radiography. One must work with "naked" film (if possible monolayer): films which have been taken out of their envelope and put directly in contact with the picture layer of the painting. A failure will result if stray radiation, from the sun or other sources, is allowed to impinge on the film.

11 Microsamples

Samples of flakes are mounted in a polyester resin. This is a fluid in its monomer form, but it is polymerized in the course of a few hours at room temperature by a small amount of catalyst (an organic peroxide) and of an accelerator (an organic salt of cobalt).

The resulting block is hard and transparent and resembles glass. The resin block is ground in a plane perpendicular to the embedded layers of paint. The flat section is further polished using abrasive aque-

ous suspensions of alumina. The making up of cross sections of paint has been mentioned in many publications over the last sixty years. The process was perfected to its present form in several laboratories. One of the better descriptions of the method has been by

J. PLESTERS: "Cross-Sections and Chemical Analysis of Paint Samples", In *Studies in Conservation*, vol. 2, 1956, pp. 110–157.

12

See: M. KIRBY TALLEY, Jr. and KARIN GROEN: "Thomas Bardwell and His Technique: A Comparative Investigation Between Described and Actual Painting Technique," In *Studies in Conservation*, vol. 20, 1975, pp. 44–108.

13

See: E. MARTIN: "Notes on the Identification of Proteins in Paint Media," (title translated), *Annales du Laboratoire de Recherche des Musées de France*, 1975.

14 Dating methods

Dating wooden panels by the method of dendrochronology is still at an early stage. The following studies can be consulted:

J. BAUCH, D. ECKSTEIN, G. BRAUNER: "Dendrochronologische Untersuchungen an Gemäldetafeln und Plastiken," Sonderdruck aus *Maltechnik/Restauro*, 1974.

J. BAUCH, D. ECKSTEIN and M. MEIER SIEM: "Dating the Wood of Panels by a Dendrochronological Analysis of Tree Rings," In *Nederlands Kunsthistorisch Jaarboek*, vol. 23, 1972, pp. 485–496.

15

Consult the works of:
C. LAHANIER: "La microfluorescence X appliquée à l'étude des peintures," *Annales du Laboratoire de Recherche des Musées de France*, 1973.

16 Castaing's electron microprobe

The electron microprobe is now used to solve many problems of substance analysis where samples studied are minute often being of the order of micrometers.

This method is well suited to the study of sections of paintings, polished surfaces, or thin slices, where *in situ* and in a non-destructive manner this electron beam can explore layers of paint of only a few tens of microns in depth, of which the composition is different and where the elements comprising its makeup could not be mechanically separated. All analyses are feasible as long as the dimensional criteria and the scanning method can be used. Within each layer the particular spectrometry can identify the elemental composition of each microprobe of the material. The power of resolution inherent in the method, gives a type of analysis infinitely superior to the best optical instruments. See:

S. DELBOURGO: "Notes techniques sur l'utilisation de la microsonde électronique," *Annales du Laboratoire de Recherche des Musées de France*, 1971.

17

See: B. KEISCH and HOLLY H. MILLER: "Recent Art Forgeries: Detection by Carbon 14 Measurements." In *Nature*, vol. 240, 1972, pp. 491–492.

18 Other advanced techniques

We should also mention the work currently being carried out using the techniques of optics and physics, namely *electrography*, which involves bombarding the work under scrutiny with severe X-rays (250 kV) and recording the secondary rays that are emitted.

Holography is a technique that uses coherent light (a laser beam). It has three possible applications:

a) *Holographic image of the surface of a picture*

The hologram has better definition than a normal photographic image and records the relief of a painting's surface.

b) *Holographic picture of damage to the painted surface*

This requires double exposure of the photographic negative. Changes in the surface due either to temperature or humidity variations reveal areas of interference that correspond to the damage wrought on the painting. In cases like this it is the technique of interferometry which is used to demonstrate the state of the painted surface.

c) *Fourier's diffraction spectrum of a photographic negative*

Coherent light enables the researcher to use the dispersion of the negative's spatial frequencies and thereby produce evidence of the state of a painting. *AGA 680 thermovision* is a technique used to measure the surface temperature of frescoes, murals and painted canvasses. It is being developed in Italy.

19 Relative humidity (RH)

There is little point in considering how much water vapour is contained in a fixed volume of air when one considers that warm air can contain more water vapour than cold air. If one divides the actual humidity of the air sample by the amount of water vapour that the sample could contain at the defined temperature and multiplies this by 100, one has a measure of relative humidity (RH) expressed as a percentage. Thus fully saturated air has a relative humidity of 100% whatever its temperature, and perfectly dry air has a relativity of 0%. Art objects kept at a constant relative humidity will not lose or gain humidity from their surroundings, even if the temperature varies (within reasonable limits).

20 Instruments measuring humidity

To measure the level of relative humidity one can choose amongst a number of apparatus, theory and design according to the situation in which relative humidity needs to be studied.

Apparatus measuring condensation point: It consists of a mirror whose temperature can be accurately measured and which can be cooled at a pre-determined rate. As the temperature decreases there will be a point where dew or condensation will collect on the mirror. This is the condensation point where the surrounding air would normally be saturated

with 100% humidity. The higher the relative humidity of the air to be studied, the less one needs to cool the mirror to reach the condensation point. After several measurements, one consults a table of water vapour pressures which take into account the temperature of the air analysed; it gives the relative humidity. This method is useful in measuring the relative humidity of microclimates such as drawers, glass cases, and other recesses, which could have a different humidity from the general atmosphere of the room.

Hygrometry: An hygrometer characteristically has two thermometers: one directly in contact with the air to be measured, and the other sheathed by moist muslin. Evaporation from the muslin will take place at a rate dependent on the dryness of the ambient air, and the temperature of the wet thermometer will be well below that of the dry thermometer. In a saturated atmosphere no evaporation from the muslin will occur, and the two thermometer readings will not differ. The relative humidity is read off from a table coming with the apparatus with the two required readings which are that of the wet and dry thermometer. To get more rapid and precise readings, one can circulate a current of air over the wet thermometer using an electric ventilator or a small clockwork apparatus within the instrument. The sling type hygrometer is designed like a hand rattle whereby the two thermometers are held in a frame which is rotated around the handle. The best design of this type is that by Assmann.

To get the best accuracy from the hygrometry reading two precautions are necessary: Firstly, the scale of the thermometers should be as large as possible with many graduations.

Secondly, stay as far away as possible from the apparatus whilst relative humidity is being measured because the human body can influence the temperature and the water vapour content of its immediate surroundings.

The hair hygrometer: This is the most commonly used apparatus for measuring relative humidity. It is based on the property of human hair – replaced by synthetic fibre – to lengthen or contract depending on the humidity. These changes are transmitted to a needle which draws on a rotating drum. There are many types of portable apparatuses some of which, when linked to an electric circuit can activate a feedback mechanism or start an alarm. They must be tested and standardized every three to four months using a hygrometer or a dew point apparatus.

21 Equipment for humidity control

There are many kinds of commercial humidifiers and dehumidifiers. Controlled machines provide a sensitive microclimate when they are equipped with automatic regulators set off by hygrostats.

Apart from these mechanical considerations, the apparatus should have sufficient capability to serve the size of the room; be easy to use and maintain; function silently; and be able to integrate as aesthetically and as practically as possible considering its size in relation to its surroundings. There are several designs:

Centrifugal humidifiers: These machines have a ventilator which sucks up a current of air and blows it onto a water-feed: the water is vaporized into small droplets. There are certain undesirable effects with this machine. In certain conditions the vapour can settle to form a moist coating. These machines

must be kept clean otherwise calcereous or other deposits may form on the works of art. The purity of the water is important, and it is, therefore, preferable to use demineralized water to prevent tartar formation and other projections within the machines which could pave the way for corrosion of metalic objects. If one takes these precautions, this type of machine can be very useful, whether it is portable and contains its own supply of water or whether it is directly connected to the water supply, and thus automatically refilled.

It is suggested that this machine be placed at a suitable height in the room and away from fragile objects.

Evaporating humidifiers: Water vapour and air mixtures are obtained by passing dry air over a material which is impregnated with water. Ambient air is sucked into the ventilator and passes through a filter, then through a net of moist synthetic cloth. The net is stretched over a rotating drum which is periodically wet by plunging it into a water basin. Humidified air emerges from the top of the machine. This system does not cause mist nor calcereous projections. It is nevertheless recommended to clean the water reservoir at frequent intervals. This machine can connect to a water supply, and when it is fitted with a hygrostat, it can automatically increase the humidity of the air when the ambient humidity becomes too dry.

There are two categories of dehumidifiers: Refrigerating dehumidifiers: Humid air coming from the room is sucked into the apparatus and is then blown onto the condensing tubes of an electric refrigerator. This cools the air below the condensation point, and the water is collected and run off. Machines of this type are simple in construction and design and easily transportable.

Desiccating dehumidifiers: The principle is to pass humid air over an absorbent material such as silica gel which absorbs excess humidity. One can regenerate the desiccated material by heating it.
Silica gel: In a closed display case one can use silica gel which absorbs any humidity present and is placed in little containers.

22 Light measuring equipment

Light meter: An apparatus which gives a direct reading of the light intensity of a particular surface, or scene. This apparatus does not react to infra-red or ultra-violet radiations.

Ultra-violet light meter: This apparatus is a practical measure of ultra-violet light which cannot be detected by the light meter. However, because it is based on a principle of fluorescence, its sensitivity does not vary as a function of the wavelength. Thus where there are small doses of short wavelength ultra-violet, which is a type of ultra-violet dangerous to many art objects, these cannot be detected. In this sense, the apparent precision of the apparatus is rather dangerous.

Thermocolourimetry: This apparatus measures the relationship between emitted light in two regions of the spectrum and deduces directly a practical estimation of the temperature of the colour of the source. The higher the temperature, the higher the proportion of blue; and the lower the temperature, the lower the proportion of red in the observed light

seen from the instrument. This translation of temperature into colour, can only be applied where the luminous source of rays is also thermally active. This is the case with the sun and other energy sources, whether artificial or natural. There are many types of thermocolourimeters. And it is preferable to consult a specialist for the choice and best use of a suitable apparatus.

SELECTED BIBLIOGRAPHY

The reader will not find the complete bibliography of works which were used in the preparation of this volume, but only those which seem most practical and accessible.

The reader who wishes to deepen his knowledge of the subject should in the first instance consult the bibliography *Art and Archaeology Technical Abstracts* published by the International Institute of Fine Arts, New York University, for the International Institute for Conservation of Historic and Artistic Works, London, since 1966. For earlier works, the reader should look at the published bibliography in one of our works *A la Découverte de la Peinture*, Arts et Métiers Graphiques, Paris, 1957.

Analysis of paintings

Periodical Publications, Series

Most of the articles in these periodicals are relevant. They are not quoted individually in the pages which follow, except when they are of outstanding interest, because there are too many of them.

Archaeometry, Oxford University, Research Laboratory for Archaeology and the History of Art. London: 1958–.

Art and Archaeology Technical Abstracts. Formerly IIC Abstracts, 1955–1965. London: 1966–.

Bijutsu Kenkyo, The Journal of Art Studies. Tokyo: 1932–.

Museum. Paris: 1948–.

Science for Conservation. Tokyo: 1964–.

Studies in Conservation, The Journal of the International Institute for the Conservation of Museum Objects. London: 1952–.

Studies in the History of Art. Washington, D.C.

Technical Studies in the Field of Fine Arts. 10 vols. Cambridge, Mass.: 1932–1942. Reprinted: New York, London: 1975.

General Works

VAN ASPEREN DE BOER, J.R.J. *Infra-red Reflectography (Earlier European Paintings).* Amsterdam: 1970.

BRADLEY, M.C. *The Treatment of Pictures.* Cambridge, Mass.: 1950.

BURROUGHS, A. *Art Criticism From a Laboratory.* Boston, Mass.: 1938.

DOERNER, M. *The Materials of the Artist and Their Use in Painting.* Translated by E. Neuhaus. 2 vols. New York: 1960.

EASTLAKE, C.L. *Methods and Materials of Paintings.* 2 vols. New York: 1960.

FARMAKOVSKI, M.W. *Preservation and Restoration of Museum Collections.* Moscow: 1947.

FELLER, R.L.; JONES, E.H. and STOLOW, N. *On Picture Varnishes and Their Solvents.* Oberlin, Ohio: 1959.

FLEMING, STUART J. *Authenticity in Art: The Scientific Detection of Forgery.* Bristol, London: 1975.

GETTENS, R.J. and STOUT, G.L. *Painting Materials.* New York: 1966.

HOURS, M. *Les Secrets des Chefs-d'Œuvre,* Paris, London, New York, Tokyo: 1964.

KURZ, O. *Fakes – A Handbook for Collectors and Students.* London: 1953.

LAURIE, A.P. *The Technique of Great Painters.* London: 1949.

MAKES, F. and HALLSTRÖM, B. *Remarks on Relining.* Stockholm: 1972.

NYQUIST, R.A. and KAGEL, R.O. *Infra-red Spectra of Inorganic Compounds.* New York: 1971.

PLENDERLEITH, H.J. and WERNER, A.E.A. *The Conservation of Antiquities and Works of Art: Treatment, Repair and Conservation.* London: 1972.

RAGGI, M. A. and BERTOCCHI, G. *Analytical, Chemical-Physical and Radiochemical Techniques in Conservation Studies.* Bologna: 1975.

RAWLINGS, F.I.G. *From the National Gallery Laboratory.* Preface by Sir W. Bragg. London: 1940.

STOUT, G.L. *The Care of Pictures.* New York: 1948.

SYKES, G. *Disinfection and Sterilisation.* 2 ed. London: 1965.

DE WILD, A.M. *The Scientific Examination of Pictures.* London: 1929.

Conjoint Publications

Application of Science in Examination of Works of Art, Proceedings of the Seminar: Sept. 7–16, 1965. Boston, Mass.: no year given.

Conservation of Paintings and the Graphic Arts, IIC Lisbon Conference: October 9–14, 1972. London: preprints.

Studies on Old Art Objects through Optical Methods. Tokyo: 1955.

THOMSON, G. ed. *Contributions to the London Conference on Museum Climatology.* London: 1968.

THOMSON, G. ed. *Recent Advances in Conservation.* London: 1963.

Selected Articles

VAN ASPEREN DE BOER, J.R.J. "Reflectography of Paintings Using an Infra-red Vidicon Television System." In *Studies in Conservation.* 14 (1969): 96–118.

BUTLER, M.H. "Polarised Light Microscopy in the Conservation of Paintings." In *Centennial Volume of the State Microscopical Society of Illinois.* Chicago, 1970.

ELZINGA-TER HAAR, G. "On the Use of the Electron Microprobe in Analysis of Cross Sections of Paint Samples." In *Studies in Conservation.* 16 (1971): 41–55.

FELLER, R.L. "Induction Time and Auto-Oxidation of Organic Compounds." In *Bulletin of the American Institute for Conservation.* 14 (1974): 142–151.

FELLER, R.L. "Scientific Examination of Artistic and Decorative Colorants." In *Journal of Paint Technology.* 44 (1972): 51–58.

FRIELE, L.F.C. "A Comparative Study of Natural and Xenotest Exposure Conditions for Measuring Fading and Degradation." In *Journal of the Society of Dyers and Colourists.* 79 (1963): 623–631.

OLIN, J. "The Use of Infra-red Spectrophotometry in the Examination of Paintings and Ancient Artifacts." In *Instrument News.* Norwalk, Conn.: The Perkin-Elmer Corporation. 17 (1966): 1–4.

TWASAKI, T. "Report from the Laboratory of Louvre Museum." In *Scientific Papers on Japanese Antiques and Art Craft.* 10 (1955): 13.

THOMSON, G. "Impermanence – Some Chemical and Physical Aspects." In *Museum Journal.* 64 no. 1 (1964): 17–36.

WERNER, A.E.A. "Chemistry and Physics of Artist's Materials." In *Proceedings of the Chemical Society.* London: (December, 1961): 468–475.

WERNER, A.E.A. "The Scientific Examination of Paintings." In *The Royal Institute of Chemistry.* no. 4 (1952): 16.

Climate – Lighting

FELLER, R.L. "Control of Deteriorating Effects of Light upon Museum Objects," In *Museum*. 17 (1964): 57–98.

FELLER, R.L. "Problems in Reflectance Spectrophotometry." THOMSON, G. ed. In *Contributions to the London Conference on Museum Climatology*. September 18–23, 1967. London: (1968): 257–269.

KEITZ, A.E. *Light Calculations and Measurements*. London: 1971.

KORTUM, G. *Reflectance Spectroscopy*. Berlin, New York: 1969.

THOMSON, G. "Annual Exposure to Light within Museums." In *Studies in Conservation*. 12 (1967): 26–36.

THOMSON, G. "A New Look at the Colour Rendering, Level of Illumination, and Protection from Ultra-Violet Radiation in Museum Lighting." In *Studies in Conservation*. 6 (1961): 49–70.

THOMSON, G. "Paper for the Working Party on Lighting." In *ICOM Conservation Committee*. Madrid: 1972.

INDEX

Amide Black, 86

Analysis: of binding materials, 94; of elements, 93, 94; of pigments, 92; of samples, 83–86; scientific, 10, 15, 90; spot, 75

Art History, 20, 72, 75, 89

Artist's Style: under infra-red rays, 62; by photo-macrography, 33–34; under tangential light, 24–27; by X-rays, 72, 75

Atmosphere, 10, 22, 34, 102

Bathsheba. See Rembrandt

Battle of Anghiari. See Leonardo

Betrothal of Arnolfini. See Van Eyck

Bianchi, 15

Binding materials, 94–96

Bitumen, 10

Botticelli, Sandro, Primavera, 10

Canvas, 10, 22, 24, 100

Caravaggio, 82

Carpaccio, 59

Caylus, Comte de, 15

Chaptal, 15

Charles, 15, 17

Chevreul, 15

Chromatography, 94, 96

Climate, 99–102

Compounds, 89

Conservation, 10, 20, 21

Corot, Camille, 24

Courbet, Gustave, 39

Cracking, 34, 37

Cradle, 67–68

Craquelure, 34, 46, 84

Crystalline structure, 94

Curves, 23

Daguerre, 15, 17

Dating, 96–97

Davy, Sir Humphrey, 15, 17

Dendrochronology, 89

Dextrins, 89

Distortions, 23

Electromagnetic radiation, 18

Electronic microprobe, 86, 93

Engraving paintings, 17

Environment, 10

Ernou, Chevalier, 59

Fabroni, 15

Fatty acids, 86, 89

Filters, 103, 106

Flaking, 22, 34

Flemish Primitives, 34, 62

Flemish School, *Virgin and Child*, 12

Fluorescence, 42

Fluorescent antibodies, 89
Fluorescent tubes. See Light, artifical
Fontenay, Belin de, 62
Forgery, 68, 82
Fouquet, Jean, *Portrait of Etienne Chevalier,* 62
French painting, 34
French school, *Portrait of François I,* 24
Fuchsin S, 86

Geiger, 15
Glaze, 37, 46, 59, 75
Gold leaf, 39
Ground, 39, 67–68, 83, 86

Herschel, Sir William, 56
History. See Art History
Holbein, Hans, 62
Humidity, 99–101
Hygrometer, 101

Impasto. See Pigments
Incandescent lamps. See Light, artificial
Infra-red rays, 56–62; in absorption spectrography, 94
Ingres, Jean-Auguste Dominique, 107, *Portrait of Cherubini,* 10
Inscriptions, 30, 52
Iodine, 89
Isotope proportions, 97

Landscape with Ruins. See Rubens
Leonardo da Vinci, 10, 39; *Battle of Anghiari,* 10; *Mona Lisa,* 75, 100
Light, 20, 102, 104, 105; artificial, 105–106; natural, 105. See also Monochrome sodium light; Tangential light
Lithography, 17
Lorraine, Claude, 17

Lucretius, *De Rerum Natura,* 56
Luxmeter, 106

Madder, 86
Magnifying glass, 37
Malraux, André, 17
Manet, Edouard, *Olympia,* 75
Mantegna, Andrea, 59
Master of Moulin, *Nativity of Autun,* 10
Mellon Institute, 97
Microsampling, 83
Microscope, 12, 37, 38, 39
Mineral ions, 89
Mona Lisa. See Leonardo
Monet, Claude, *The Terrace at Sainte Adresse,* 33
Monochrome sodium light, 29–30
Musées de France: Research Laboratory, 93
Museological research, 93
Muses, The, See Sueur, Le

Nativity of Autun. See Master of Moulin
Neutron activation, 94, 97
Niepce, Nicéphore, 15, 17

Olympia. See Monet

Paint layer, 83, 84
Panchromatic film, 29
Pasteur, Louis, 15
Photographs: fluorescent, 52, 55; infra-red, 59; monochrome sodium light, 29; tangential light, 22
Photography, 15, 17, 59
Photomacrographs, 27, 30–37
Photomicrography, 30, 37–40
Pigments: under infra-red rays, 59; effects of light on, 105; microsample of, 83; photomacrograph of, 34–37; photomicrograph of 37–39; effects of

pollution on, 102; under tangential light, 21, 27; X-rays of, 64, 72
Plaster, 72
Plastic, 86
Pollution, 102–103
Polysaccharides, 89
Portrait of Cherubini. See Ingres
Portrait of Dr. Gachet. See Van Gogh
Portrait of Etienne Chevalier. See Fouquet
Portrait of François I. See French school
Portrait of a Young Man. See Rembrandt
Preservation, 21, 27, 52, 90
Primavera. See Botticelli
Primer, 27, 39
Primitives, 75
Proteins, 86, 89

Radiography. See X-Rays
Raking light. See Tangential light
Refixing, 22
Reflectography, 62
Rembrandt, 62, 65; *Bathsheba*, 75; *Portrait of a Young Man*, 75, 84
Repairs, 33
Restoration, 14, 37, 52, 84
Restorer, 55, 57, 89
Retouching, 45, 84
Roentgen rays. See X-Rays
Rubens, Peter Paul, *Landscape and Castle Ruins*, 51

Scales, 22
Scanning, 93
Signatures, 30, 39, 52, 59
Sketches, 27, 72, 75
Staining. See Analysis
Stains, 86, 89
Starches, 89

Stratigraphical technique, 68
Struts, 67
Subsidence, 34
Sudan Black, 89
Sueur, Le, *The Muses*, 66
Support: analysis by staining, 89; lighting of, 165; metal, 67; paper, 24; photomacrograph of, 34; under tangential light, 22–24; textile fibres, 90; X-rays of, 67–68. See also Canvas; Wood
Surface, 21, 45

Tangential light, 20, 21–27
Temperature, 99, 107
Terrace at Sainte Adresse, The. See Monet
Thermometer, 101, 106

Ultra-violet rays, 42–56, 92–93
U-shaped tube, 27

Van Eyck, Jan, 30, 107: *Betrothal of the Arnolfini*, 62; *Virgin of Autun*, 99
Van Gogh, Vincent, 27; *Portrait of Dr. Gachet*, 30
Varnish: analysis by staining 86; under infra-red rays, 57; microsample of, 83; photomacrograph of, 37; effects of pollution on, 102; revarnish, 52; under tangential light, 21; under ultra-violet fluorescence, 45
Vauquelen, 15
Vibration, 103–104
Virgin and Child. See Flemish School
Virgin of Autun. See Van Eyck

Wedgwood, 17
White lead, 72, 97
Wood, 10, 23, 24, 34, 68, 99

X-Rays, 20, 42, 55, 62, 63–82; diffraction, 94; microfluorescence, 93; spectrometry, 93; stratigraphical technique, 68

The documents illustrating this book come from the archives of the Laboratoire de Recherche des Musées de France and were prepared by A. Tournois and M. Solier, except for Nos. 34, 35, 36 reproduced by courtesy of the Munich Pinakothek, Nos. 41 and 42, courtesy of the Director of the National Gallery of Art, Washington, D.C. and published in *Studies in the History of Art* 1972–73, and Nos. 67–68 reproduced by the courtesy of the Central Restoration Institute, Rome.

We should like to express our appreciation to our French and foreign colleagues who contributed to the illustration of this book,

This book was printed by Imprimerie Hertig + Co. S.A., Bienne in March, 1976. Photolithographs by Kreienbühl + Co. S.A., Lucerne. Binding by Burkhardt S.A., Zurich. Layout and production: Yves Buchheim. Editorial: Barbara Perroud.
Printed in Switzerland.